Iconic Restaurants

OF

COLUMBIA

— MISSOURI —

KERRI LINDER

AMERICAN PALATE

Published by American Palate
A Division of The History Press
Charleston, SC
www.historypress.com

First published 2018

Manufactured in the United States

ISBN 9781467139304

Library of Congress Control Number: 2018948045

This book is dedicated to Mimi, who never missed an opportunity to celebrate life with good friends, great food and a perfectly prepared cocktail.

Contents

CONTENTS

Acknowledgements

A s a native Columbian, I have witnessed many aspects of the city's growth, including the success, phasing out and sometimes failure of restaurants in Columbia's history. It has been my pleasure to share Columbia's history as part of operating Columbia Culinary Tours the last few years, so when I was asked by Chad Rhoad, senior commissioning editor at The History Press, to do this book, I knew it would be challenging but fun to research a subject matter I already loved. I appreciate Chad Rhoad's guidance and patience with all my questions throughout the process of this book.

There were so many Columbia residents of the past and present who contributed their stories and helped make connections with former restaurant owners that I can't possibly name all of them. However, I have to give a huge shout-out and thank-you to the followers of the Facebook page "You know you're from Columbia MO when...." Whenever I asked questions about restaurants to this group, they never disappointed! Many of them are quoted in the book, and many more shared stories, introduced me to others with connections to restaurants of the past and even gave me the use of their personal photograph collections. I also had the pleasure of visiting with and interviewing several owners of past and present restaurants, and their input and stories were invaluable. Thank you to all of you for taking time out of your busy schedules. This has definitely been a community collaboration!

The Boone County Historical Society and Daniel Boone Regional Library staff were very helpful in directing me toward different historical resources. I can't thank the research center staff at the State of Missouri Historical

ACKNOWLEDGEMENTS

Society enough, especially Heather Richmond, Anne Cox and Laura R. Jolley. Your patience with all my questions and collection requests, as well as your enthusiasm for the subject matter, made tackling almost two hundred years of local history much less overwhelming.

Just as many people quoted in this book remember traditions revolving around Columbia restaurants, I, too, have treasured memories of meals spent in many of the places featured in this book. As I wrote about these iconic places, it brought to mind so many meals, milestone celebrations and special treats shared with friends, coworkers and especially family throughout my childhood and adult years. Many of those who helped make those memories are no longer with us, and I have truly enjoyed reliving those moments during the writing process. Thank you to all who helped create those happy memories!

My deepest appreciation goes to my husband, Chad, and kids Allie, Spencer, Carson and Will. The unending support, patience and encouragement I have received from all of you throughout this entire process has meant more to me than words can express. I don't take for granted what an awesome cheerleading crew I have. A special thank-you to Chad for always being a willing proofreader and enthusiastic fan of my writing and every other challenge I take on. I know how lucky I am to have you by my side!

Introduction

To understand the evolution of restaurants in Columbia, it is helpful to look back at how the city made it on the map of Missouri. Columbia is often referred to as a college town, and it is deserving of that description, as three colleges are adjacent to the downtown area: Columbia College on the north, Stephens College on the east and the University of Missouri on the south. The downtown area has a wide variety of culinary offerings as diverse as the college students, faculty, visitors and locals who frequent them. There are also several wonderful restaurants farther away from the central downtown area. Columbia's restaurant scene has reflected the changing times in both the menu items that are offered as well as their locations within the city.

The city that is the county seat of Boone County may be known as an educational destination today, but it started out with true pioneer spirit in the Wild West frontier. The area that is now known as Columbia was purchased at a government land auction after the Louisiana Purchase, when the country was encouraging westward expansion. The pioneer credited with starting Columbia, Colonel Richard Gentry, headed up the Smithton Land Company that purchased the land that was to later become Columbia. Colonel Richard Gentry and his wife, Ann Hawkins Gentry, truly embodied the pioneer spirit and traveled to Missouri from the state of Kentucky. It is written in family papers that Mrs. Gentry rode horseback from Kentucky on a racing mare, holding an infant in her lap, with her two-year-old child holding on behind her! The Gentrys operated the first "restaurant" in Columbia, which you will read about later in this book.

After stops in St. Charles and Franklin—both thriving Missouri river towns at the time—they settled in about a mile west of the current downtown area of Columbia and named it Smithton. After they dug wells and were unsuccessful in striking fresh water, the decision was made to pack up and move closer to the Flat Branch Creek in the area that is now known as downtown Columbia. The name was changed, and Columbia became a city the same year that Missouri became a state, 1821.

The citizens of Columbia had to find a way to grow their new city. The Boone's Lick Trail (later spelled Boonslick), named after frontiersman Daniel Boone's sons, who discovered and mined a salt lick in nearby Franklin, Missouri, was a heavily traveled trail across Missouri and ran about six miles north of Columbia from St. Charles to Franklin, Missouri. It eventually linked up with the more heavily traveled Santa Fe Trail. Colonel Richard Gentry lobbied to have the trail moved, and eventually a sign with "shortcut" was placed north of town and the settlers used their tools to cut a one-hundred-foot-wide path through the center of the new town. This brought westward travelers, and their money, through Columbia on the road that is now called Broadway and serves as one of the main roads in the city. What started as a pioneer settlement is now a thriving college and business town. A historical look back at its restaurants shows the progression and adaptations that Columbia's entrepreneurial citizens have offered to hungry travelers, students and settlers in this thriving Midwest city.

In determining the list of restaurants to feature, it quickly became evident that it would be impossible to feature all of the restaurants deserving of mention in this nearly two-hundred-year-old city. With today's technology, pictures of restaurants, culinary masterpieces and patrons enjoying those restaurants are abundantly available. However, this was not the case even decades ago, so many of the restaurants of the past have limited documentation, and it was hard to truly paint a picture of the importance they hold in the memories of those who ate in those establishments. Fortunately, Columbia residents include many locals whose families have been in Columbia for generations and have passed down their stories, diaries, letters and news clippings, which include many references to popular and favorite restaurants of the time. Several of those same restaurant owners' families still reside in Columbia and have graciously shared their time, memories and treasured photos with me as I have tried to piece together a true representation of the importance those restaurants have had in the history and shaping of Columbia. A common thread has been unending work ethic among the owners—no doubt a holdover of the pioneer spirit that started the city. It

was also evident that the sense of belonging to the community and of being welcomed at a favorite restaurant was just as much a factor as the food in being considered one of Columbia's iconic restaurants.

The term *restaurant* is used to encompass many different eating establishments, including taverns, inns, cafés, diners, drive-ins and even specialty food and drink shops. Columbia has been fortunate to have a wide variety of culinary options to satisfy its appetite for great food and drinks, whether very casually at its many diners and drive-ins or for upscale fine dining and everything in between. Although this book is not representative of all Columbia's iconic restaurants, I was privileged to interview many of the owners, family members, employees and customers and include their cherished stories and memories in this book. There are many featured restaurants that no longer have anyone living that can share their experiences, and for those, I was able to rely on family collections of manuscripts and photographs on record, as well as old newspaper and magazine articles, so their place in Columbia's culinary history could be included.

Our college town is still home to several featured restaurants that opened several decades ago and continue serving up nostalgia to new generations. For those places that no longer exist, enjoy experiencing some of the stories, menus and photos that bring the lost restaurants of Columbia back to life.

Early Taverns along the Boonslick Trail

As westward travelers made their way across Missouri and through Columbia, a need to provide them with a welcoming place to rest and satisfy their appetites quickly arose. The taverns in the area all had a similar layout, with a large fireplace, a bar and dining tables. The menus were consistent from tavern to tavern and included whatever could be hunted in the area. The standard price of a meal was twenty-five cents. The majority of the meat was wild game: venison, turkey, prairie chicken, duck and goose. Since there was no refrigeration, smoked and pickled pork products were often served, but fresh beef was a rarity. There was not a lot of variety in fruits and vegetables, but potatoes, pumpkins, cabbage and apples were seasonably available.

Among the early taverns were taverns with the names of Gentry, Selby and Camplin. There is not a great deal of information recorded about these early taverns, but it is clear they set the stage for creating a place for a sense of community and gathering over a meal.

THE GENTRY TAVERN

Gentry's Tavern was the first and most famous tavern. It was started in the community of Smithton in 1819 and then was moved by oxen to the newly created city of Columbia, half a mile away, in 1821. It was located

on the Boonslick Trail and was also the Gentrys' home. Hungry and tired westward travelers traveling on the Boonslick Trail could find a meal and a place to rest themselves and their horses for the night at the Gentry Tavern. Colonel Gentry was a colorful character and had been tried for murder before moving to Columbia. He was acquitted but probably thought it best to make a fresh start elsewhere. Richard Gentry was also the first mayor of Columbia, elected state senator in 1826, appointed postmaster in 1830 and a colonel in the Missouri militia, so the tavern not only served meals, but it was also the post office, stagecoach stop and headquarters for civil and military defense. The University of Missouri opened in 1839, and its first commencement (of a class of two cousins) was held in 1843. A procession from Gentry Tavern to the university chapel kicked off the event.

Ann Hawkins Gentry also made her mark in history at this tavern. When Colonel Richard Gentry died in battle on Christmas Day 1839 in the Florida Seminole Wars, his widow, Ann Hawkins Gentry, was appointed the new postmaster. It was considered controversial, and possibly illegal, to give this position to a woman, but after some convincing from a family friend, Senator Thomas Hart Benton, President Martin Van Buren appointed Ann Hawkins Gentry the first female postmaster in the United States. Although there had been a female postmaster in the United Colonies, the Gentry family credits Ann Gentry with being the first in the new country. The Gentry Tavern remained open until the year of Ann Gentry's death, 1870.

SELBY'S TAVERN

Another early tavern was Selby's Tavern, owned and operated by Thomas Selby from 1832 to 1845. It was located on the southwest corner of Broadway and Eighth Street. It had the distinction of including famous author Washington Irving as one of its guests on September 19, 1832. An expense account jotted down by Abiel Leonard of Fayette, a lawyer in Columbia for a two-week court case in October 1844, totaled $10.62— including lodging for himself and his horse and a washing. Thomas Selby went on to open several other tavern/hotels within a few blocks of one another, including Selby's Hotel a few doors east of his tavern from 1844 to 1852. From 1855 to 1871, Selby also owned City Hotel on the southeast

corner of Eighth and Walnut Streets. An idea of what was served to diners can be gained from an ad in the *Missouri Statesman* dated September, 17, 1858, that reads, "We wish to buy all kinds of Game, such as Rabbits, Squirrels, Turkeys, Quails, Ducks, Venison and Chickens. Also all kinds of Vegetables, for which the highest cash prices will be paid."

CAMPLIN'S HOTEL

Although "hotel" is in the name, Camplin's was set up and operated as a tavern in the 1840s. It was owned by Edward Camplin, who couldn't read or write, but that didn't stop him from being a successful innkeeper. He is credited with donating $3,000 to the fund for securing the University of Missouri's location in Columbia; his was one of the largest contributions to the fund.

A number of factors led to the demise of the early taverns in the decades after the Civil War: the covered wagons that brought thousands of migrants through Columbia were replaced by the transcontinental railroad, freeing of slaves ended low-cost domestic service, the depletion of the once abundant wild game ended the taverns' cheap supply of meat and laws associated with the prohibition movement interrupted the taverns' revenue from liquor sales. This set the stage for the next type of dining and accommodations establishment: the small hotel.

Small Hotels

Transitioning from Pioneers to Post–Civil War Travelers

Although taverns were phased out after the Civil War, the college and university functions—including commencement and several statewide conferences—which made the central location of Columbia attractive, created a need for more rooms, as well as banquet and meeting spaces. An ad for the Columbia Hotel from the *Jefferson City Inquirer* dated November 2, 1857, indicates the food served at hotels was important to potential boarders. The ad states, "His table is always supplied with the VERY BEST THE MARKET AFFORDS, served up by an experienced cook." A number of hotels were established during the years leading up to the turn of the century. Some were small, some were larger, but all shared in the history of developing Columbia. The hotels not only served as overnight accommodations but also had restaurants that provided gathering places for dining.

In the early 1880s, Lizzie Powers turned the former three-story home of Richard C. Branham, a wealthy Columbian merchant who died in a ship fire, into a hotel. It was located across the street from the Wabash train depot, so it was the first place that visitors to Columbia saw when they arrived by train. It changed ownership over the years and became popular as a meeting place and for its banquets. William J. Bryan attended a political banquet there during his 1896 presidential campaign. It also hosted many after-dance banquets for students. A fire closed the hotel in 1939.

There were several other hotels during that time that catered to overnight guests as well as diners. The Planters' House enjoyed a location

in the center of activity across from the courthouse square. The Athens Hotel was located across the street from the Planters' House. The Cottage Hotel was located closer to the University of Missouri. It was added onto several times over the years, and the building is currently the oldest in Columbia. It has also been the Columbia Female Academy, Gordon Hotel and Home Economics Department of the University of Missouri and is currently the Niedermeyer Apartments. This building has had many different names as its owners and function changed, but this building that is in the National Register of Historic Places has been a witness to many changes over history. When it operated as a hotel, it had the distinction of serving tea in the parlor to Mary Todd Lincoln. Like many of the buildings in Columbia, the large building served as a hospital during the Civil War. In one of the first additions to the building, the hallways are fourteen feet wide. That was to allow room for two ladies in hoop skirts with one male escort. Mark Twain, a Missouri native, gave a speech on the lawn when he was a distinguished guest for the university Department of Education graduation ceremony. If those walls could talk!

The introduction of the automobile and building of the Old Trails Route, which is the present-day Interstate 70, brought many new visitors to Columbia, along with the need for larger and more modern hotel facilities. This led to the demise of the smaller hotels.

Early 1900s Hotels

Wooing the Theater Crowds and Sunday Diners

By the early 1900s, Columbia had grown from a pioneer settlement to a thriving city. The population had multiplied from 230 citizens in 1823 to 4,000 in 1890. The National Old Trails Road was established and followed the Santa Fe Trail and Boonslick Trail through Missouri and later became Interstate 70. The University of Missouri and its athletic programs were growing. Christian Female College and Stephens College attracted students and visitors. The presence of automobiles was increasing. Recognizing these factors, the business leaders of Columbia forecasted correctly that our mid-Missouri city would become the host to many visitors who would expect modern amenities, including restaurants and banquet facilities. Attending the theater became popular during this time for both locals and visitors from the surrounding smaller communities. Many theaters were built in the downtown area to accommodate this trend, including the Hall Theater (1916), the Varsity Theater (1927) and the Missouri Theater (1928). Often, those attending the theater would also want dinner to complete the afternoon or evening out. The downtown hotels responded by including nice restaurants in their hotels for both the theater crowds and Sunday diners looking for a meal after church service. Two of the largest were Daniel Boone Tavern and the Tiger Hotel.

DANIEL BOONE TAVERN

After contributions were obtained from local businesses and citizens, plans for a large modern hotel located on the main road of Broadway in the center of the city were underway. On September 1, 1917, the Daniel Boone Tavern opened for business with one hundred guest rooms, a billiard room, a barbershop, a café and a dining room. A formal opening dinner for 250 guests was held on October 13 of the same year with a sophisticated menu, including clear green turtle soup and roast carno squab (young pigeon) as part of the five-course meal. The program included distinguished speakers, the first of whom was A.W. Douglas, vice president of the Simmons Hardware Company of St. Louis. In an excerpt of his speech, Douglas said:

> *To one who is used to wandering over the face of the world such a tavern as this means a great deal. I think this is one of the most beautiful structures of its kind on the United States. And not only do you have one [of] the finest hotels in the country in Columbia, but you also have here the school that is*

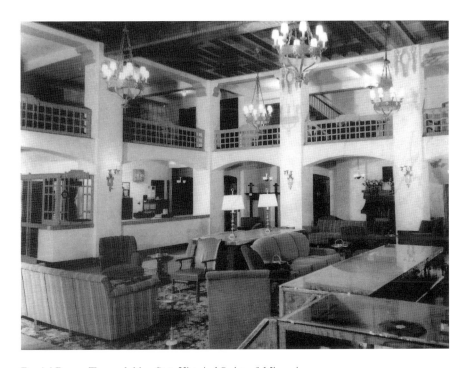

Daniel Boone Tavern lobby. *State Historical Society of Missouri.*

the dearest and most precious in my mind—the University of Missouri.…
What impresses many in St. Louis is the way Columbia has made itself a
place where people are glad to live.

The coffee shop located next to the lobby was a popular meeting spot for businessmen downtown and became a regular dining spot for the historic Round Table men's group (described later in this book). The Velvet Lounge was located inside the hotel to the immediate left of the entrance. It was a popular after-work spot during the 1950s for local businessmen. Sally Phillips, a Columbia resident of over sixty years, remembers her dad, Chub Phillips, who worked downtown, going to the Velvet Lounge and her mom, Mary Jo, calling for him there. They were friends with the owners, Jim and Mary Ruth Nanson, who lived on the top floor of the hotel.

A plaque on the front of the building shares a brief history of the historic landmark, including some of its distinguished guests over the years, such as Harry Truman and Eleanor Roosevelt. The hotel and its parties are remembered as fun and festive events to Columbians, but one rather sad event also happened at the Daniel Boone Tavern. Baseball legend Branch Rickey, best known for breaking the color barrier in major-league baseball by signing Jackie Robinson and creating the farm system, was in Columbia to be inducted into the Missouri Sports Hall of Fame. On November 13, 1965, he left a St. Louis hospital to watch the Missouri-Oklahoma football game and then later that evening attend the Sports Hall of Fame banquet at the Daniel Boone Tavern. Shortly after he began his acceptance speech, he said, "I don't believe I'm going to be able to speak any longer" and then slumped over and was taken to Boone County Hospital. He remained in the intensive care unit until his death on December 9.

By the late 1920s, the majority of downtown traffic had been rerouted north to Highway U.S. 40. Travelers who had once driven through downtown now stayed at small hotels located on the highway. In 1940, the name was changed to the Daniel Boone Hotel in an effort to market to the automobile traveler. The grand hotel building still stands prominently in the same location on Broadway, but since the late 1970s, it has housed various city and county offices and is now Columbia City Hall. Upon entering the building, the once vibrant hotel lobby is clearly evident, and a stroll down the connecting hallway to the new city building invites the visitor to take a trip back in Columbia history, with display cases containing artifacts, maps and letters from the city's past.

THE TIGER HOTEL

Another grand hotel found in downtown Columbia was the Tiger Hotel, or the Tiger, as locals refer to it. Built in 1928 and located just two blocks north of the University of Missouri on Eighth Street, the Tiger stood out in the city skyline with ten stories and was the first skyscraper between Kansas City and St. Louis. The neon TIGER sign atop the building, lit up in red, attracted travelers from Highway 40. It is original to the hotel and still serves as one of the city's most notable landmarks. The hotel quickly became a popular place for travelers looking for luxury, as well as visitors and distinguished guests of the university. Rates for a "New and Modern" room at the Tiger ranged from $1.75 to $3.50 in 1935. That might buy you a cup of coffee at a luxurious hotel in current times! The hotel has been home to several different restaurants over the years, including the Terrace Grill, City Lights, Bleu, the Velvet Cupcake and currently Glenn's Café. In reading through many local society papers, I found many mentions of luncheons and dinners for various groups held at the Tiger Hotel. It is documented in several years of Altrusa International women's club minutes that many meetings were held at the Terrace Grill, so it must have been worthy of so many repeat visits!

The Tiger has had several owners throughout the decades, even serving as a retirement community in the late 1980s. In 2012, it was restored to its original luxury and opened as a boutique hotel, complete with a full-service restaurant.

By the end of 1945, Prohibition, the Great Depression and World War II were history. The two largest hotels in the city center downtown were adapting to travelers' tastes, and listings in the 1946 city directory for Daniel Boone Hotel and the Tiger Hotel both proudly advertised "Modern & Fireproof" and "Air Cooled Rooms."

The Round Table Group

Columbia's Movers and Shakers

A book about Columbia's historic restaurants would not be complete without including the story of the Round Table men's group, which is intertwined with the downtown area historic restaurant scene and community. Columbia's restaurants have come and gone throughout its history, but a constant has been the meetings of the Round Table. The group is made up of prominent men in the community, including university faculty, civic leaders, medical professionals and business owners. The regular lunch meetings were established as a means for fellowship, sharing stories and discussing local issues. From the stories that have been passed down over time, it appears also to have been an avenue for developing lifelong friendships among members and their wives. Membership is by invitation only, after being voted on by the existing members. Walter Williams organized the original group in 1916. Williams was the founder and dean of the University of Missouri School of Journalism at the time. He became the president of the university in 1931. The group has been limited to the number that can fit around the round table of the restaurant. The name is also a tip of the hat to the Knights of the Round Table. The group has consistently met at one downtown restaurant until that restaurant has closed.

The original group routinely met at Harris Café. This group dissolved after Walter Williams's death in 1935. Meanwhile, Frank "Ramrod" Leonard, owner of the Daniel Boone Tavern, created another men's luncheon club and called it the 1930 Club. The membership of this group included influential businessmen of the community and some university

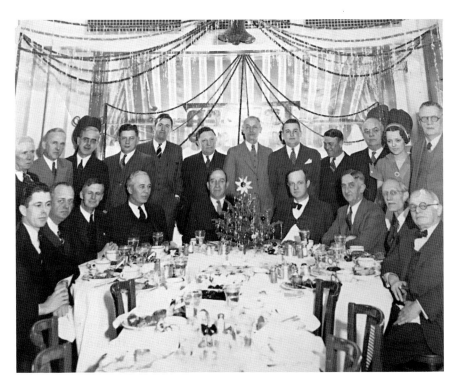

Round Table 1947 Christmas party at Daniel Boone Tavern. *Genie Rogers's scrapbook at Boone County Historical Society.*

professors and administrators. The dissolved group joined the new group, and the newly merged Round Table was formed and continues today. The membership list is a who's who of Columbia's leaders. Some of the early group members' names are still recognizable to locals today: Dr. C.W. Digges (father of the oldest current member, Charlie Digges), S. Frank Conley (family namesake for Conley Avenue and Conley Road) and L.A. Nickell (namesake of the city golf course). Some of the members listed in 1924 include Isidore Barth (owner of Barth's Clothing Store), Isidore Loeb (University of Missouri Business School professor), Walter Williams, R.B. Price (banker at Boone County National Bank), W.B. Nowell Jr. (grocer), Dr. Stratton D. Brooks (president of the University of Missouri), Dr. Charlie Digges (dentist), Jack Hetzler (merchant), Chester Brewer (University of Missouri physical education instructor and later athletic director) and Marshall Gordon (farmer).

For some, membership is a family affair. At the 1949 Christmas party, Charlie Digges Jr. was a guest. His father and founding member, Dr. Charles

Digges, had recently died, and Charlie was not able to join at the time due to being called for service in the Korean War. When he returned in 1952, he was asked to be a member and enthusiastically accepted the invitation. He is currently the oldest member of the group and is now Charles Digges Sr. because his son (who is also a Round Table member) goes by Charles Digges Jr. If you're keeping track, that's three generations of membership!

Over time, membership has been fluid as new members have replaced others who have moved or passed away. In 1970, some of the members were Charles Digges Jr. (the Insurance Group), Judge W.M. Dinwiddie (retired judge), Guy H. Entsminger (University of Missouri vice president), Don Faurot (University of Missouri athletic director and the namesake of Faurot Field), Jim Nanson (manager of the Daniel Boone Hotel), Lindsey A. Nickell (retired owner of the ice plant), Dean Parks (owner of Parks Department Store), Ed Perry (owner of Perry Chevrolet) and A.D. Sappington (president of MFA Insurance Company).

When the Daniel Boone Hotel was sold to the city, the group had to choose a new place to gather for its regular lunches. The historic Tiger Hotel was chosen as the replacement. However, the group was not ready to part with its round table and purchased it for thirty-five dollars from the city. Now how did this table with a seven-foot diameter quickly get moved the one and a half blocks to its new home? Three members—Jack Matthews, Don Faurot and Raymond Young—flipped it over, put it on wheels and rolled it right down the middle of Broadway and then Eighth Street. Problem solved!

In the 1980s and '90s, when the Tiger became an assisted living facility, the group moved to the Katy Station restaurant on Fourth Street. A bowl of free apples was always available at the Katy Station. Rumor is that member Hank Waters, former owner and editor of the *Columbia Daily Tribune*, would always take one and frequently had it for lunch. Perhaps he was just looking for a healthy alternative, but the other members didn't miss the opportunity to have some fun and gave him the title of "cheap."

Members of the group insist their lunches are not for policymaking; that would be too serious and take away from the fun. It is a social group, similar to a college honorary fraternity whose members are all male. When the group originally formed in 1916, there was an unwritten agreement that it was a men's club and women were not allowed. Women couldn't even vote until 1920, so this "rule" reflected the thoughts of the time. As the country's attitude toward women evolved, so did the policies of the Round Table. Wives were invited to the annual Christmas dinners and other social

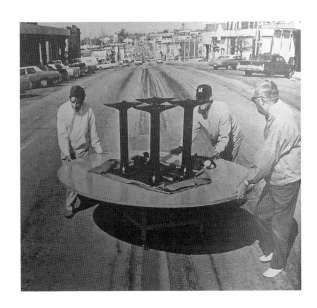

Moving the round table down Broadway to the Tiger Hotel. Columbia Daily Tribune *photo by John Freeman.*

gatherings, and female guests were welcomed to the luncheons. One such notable guest was Chancellor Barbara Uehling. She was the third chancellor of the University of Missouri–Columbia campus and the first woman in the United States to lead a land-grant university, serving from 1978 until 1986. The members considered it a privilege when their invitation was accepted and Chancellor Uehling joined them for lunch.

The bonds and memories that members have created over time are evident in a letter that local retired dermatologist Dr. Jim Roller wrote for the one-hundred-year celebration scrapbook:

> *Roundtable is always enjoyable when no seat is empty and the conversation never lags, and the rare days when one dines alone are real bummers; but the occasional times when only one other person shows are often the best. The hours I've spent shooting the breeze with Charlie Digges, Sr., were like conversations with the grandfather I never had, or the father who died too young. Another Columbia icon and member of the Roundtable was Don Faurot. Coach and I both lived in The Grasslands. One day I had stopped at home for a minute before heading to The Roundtable. As I drove down Burnam, Don's car exploded out of his driveway in front of me, barreled onto Providence Road without slowing, and continued on to the Katy Station, barely negotiating the turn at Locust and South Fourth St. We were the only attendees that day. During our conversation I mentioned that I was reading a book about The Battle of Britain, and it had listed an American pilot named Robert Faurot,*

who flew in England during that time. I asked if he were somehow related, perhaps a distant cousin. "Oh that's my brother Bob," Coach said, and then filled me in on some of his youngest brother's achievements. Through further reading, I learned of an unsung hero of Columbia, a star athlete at Hickman and MU, killed tragically in 1943 during the Battle of the Bismarck Sea. Being a member of The Roundtable was an opportunity to learn about Columbia from the people who were making the news, an opportunity to touch and be a part of Columbia's history.

The members of the Round Table seem to enjoy a reprieve from rules during their time together. Yet they still have at least a couple of guidelines they're proud of, which, according to the 1971 group, include "never agree" and "be willing to talk on any subject on any time, particularly on a topic that you know very little about." Clearly this group doesn't take itself too seriously.

In 1998, the Katy Station restaurant closed, and again the Round Table group was in need of a new meeting spot. It settled, along with its round table, at Boone Tavern on Walnut Street. Boone Tavern closed in 2012 and was replaced with Bleu Restaurant. Bleu inherited the Round Table group and its round table, with a corner spot by the front window. In June 2016, owner Travis Tucker made the decision to close Bleu Restaurant. Where would the men of the Round Table go next? They didn't have to travel far; they chose a restaurant across Walnut Street and located on the ground level of the historic Guitar Building, Room 38 Restaurant and Lounge. Unfortunately, there wasn't room for their well-traveled round table, but there was room for this group to continue the tradition of building their friendships and sense of community over regular lunch dates.

Room 38 Restaurant and Lounge continues to be the meeting place. Dan Simon, a local attorney, summarized his thoughts about the historic group as follows:

Other than Charlie Digges Sr., I am the oldest, in terms of membership, member of the RT. It, and its members who it has been my honor and pleasure to know and from whom I have learned a great deal, have been of huge importance in my life. I think of the men who have passed through my life as members of the RT since I joined in 1975 with great memories, and more than a touch of sadness. Unfortunately, life changes, and as one of our great former members, Don Faurot, told me, "I have seen a lot of changes in my life and have opposed every one of them." Like everything else in our culture, the RT has changed, and it has changed a lot, and not for the

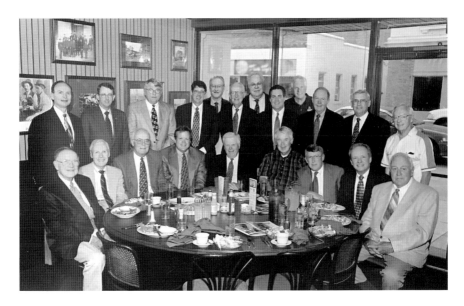

1999 Round Table lunch at Boone Tavern. *Genie Rogers's scrapbook at Boone County Historical Society.*

better. My fear (and maybe it is my fault) is that it is going to go the way of a whole lot of things, which have given us connections and relationships and have made life good and worth living. I have huge fears that, in a short period of time, the RT will be no more.

The Round Table celebrated one hundred years in 2016. Genie Rogers, the widow of twenty-five-year member and attorney David Rogers, compiled a scrapbook to document the members and events of this historical group of community leaders. She closed the scrapbook with this sentiment:

As with all things, we get out of them what we put into them. Those who participated and were frequenters at the Table received friendship, camaraderie and a sense of belonging to a very special group of men—an institution that reflects their 100th birthday this year. It is now in the process of passing the mantel to a new set of leaders, just like it did a generation or two back and before. The long time members are eager to be mentors to keep the Table relevant and it is up to the new members to make it viable for the future.

The saying goes, "All good things must come to an end." Let's hope this longtime tradition's end is very far in the future.

Cafés and Stand-Alone Restaurants

Satisfying Locals and Students on a Budget

As cars became more common and traffic was diverted to the highway, the demand for big hotels decreased, but local Columbians and students still needed places to go for a good meal and fellowship. In 1909, there were nine restaurants and lunchrooms, and all were located in the downtown area. Nationwide, cafeterias and luncheonettes thrived as more customers were looking for affordable, simple home-style food. Columbia was no exception to this trend. The 1935 telephone directory listed twenty-seven cafés in Columbia, including Annex Café, Charlie's Café, Dixie Café, Holt's Lunch Room, Topic Café and White House Lunch No 3. Most of these cafés of the past have no pictures or stories documented to show their existence. Others live on through the family of the owners, letters in donated files to the historical society and articles in archived newspapers.

Gaebler's Black & Gold Inn was located on Conley Street on the university campus. Fred Gaebler and his wife, Olinda, opened the Black & Gold in 1931. At the time, there was a city ordinance forbidding dancing on a restaurant's main floor, so the dance floor was located upstairs. It was known as a "jelly joint": a place to take your date and dance to live music. Melissa Applegate remembers her father, Jackson Naylor, talking about working at Gaebler's when he was a student at the university. Since there weren't many students who had cars at that time, it was a popular place to work and hang out for students. Although alcohol wasn't served at Gaebler's, the food was considered good and reasonably priced for a student's budget. Gaebler's was sold in the 1950s and later became the Italian Village.

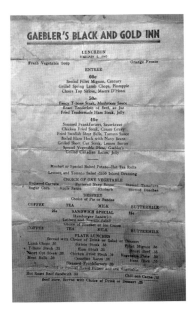

1940 Gaebler's Black & Gold Inn menu. *Collection of Melissa Applegate.*

Harris Café is another early one that shows up in various writings. The original 1916 Round Table men's group routinely met at Harris Café. Warren Dalton Jr., Columbia resident and local historian, wrote fondly about his time being employed at Harris Café when he arrived in 1935 to attend the University of Missouri: "Duck Millard, the owner, also owned a boarding house where I stayed and I worked four hours a day for my room and board; overtime pay was $0.35 per hour. That was the going rate and all the waiters survived on tips. Regardless of the bill, 25¢ was a good tip and 50¢ was great." A 1935 ad read, "Harris' where Missouri men and women meet and eat." Many locals still talk about the great food at Harris Café whenever it is brought up. Longtime local John Wilke remembers going there when Dick Creber was the owner and wrote, "Dick Creber's Harris Café epitomized fine dining in Columbia. Nothing like his pan fried chicken served with mashed potatoes and gravy family style."

The Model Lunchroom was listed in the 1935 telephone directory with an address of 11 North Ninth Street. In a March 27, 1969 article in the *Columbia Missourian*, MU alumni Sam Utz reminisces about his time in Columbia as a student from 1920 to 1923. While attending the University of Missouri, he earned his way by working at the Model Lunchroom, owned by Mrs. Bessie E. Morris. "Mrs. Morris was known as 'Mom' to many students back then," Utz said. "It was the only place for the students to eat besides the cafeteria. It had two counters and 56 stools and everyone always called it The Greasy Spoon."

AMBROSE'S CAFÉ

In the late 1920s, on a portion of Eighth Street that no longer exists, sat Ambrose's Café. The proprietor was Ambrose Hathman, a second-generation Columbian. Ambrose and his wife, Gertie, had two sons and

seven daughters, and they all were expected to work in the café. The family lived one block away on Seventh Street, so it made it easy for them to keep long hours at the café, which opened early for breakfast and served food until midnight. Ambrose's grandson Ron Coleman retells the stories passed down by his mother and aunts, including how Ambrose's children were paid for their work: "Ambrose didn't pay his daughters for their hours worked in the café, but instead had an open account at a clothing and shoe store on Broadway where they could charge whatever they wanted." With seven daughters, it didn't take long for him to realize that he would have been much better off giving them a paycheck instead!

Ambrose's was a family affair, and when daughter Bettie Jean's husband, Odell, returned from World War II, he was hired as a bartender. However, it was a short-lived position. Two hours into his first shift, he poured himself a beer and was fired on the spot. Ambrose had a strict "no drinking while on duty" policy, and even family didn't receive a pass on the rules. The armory was just around the corner from Ambrose's, so the café was a popular spot for the soldiers to enjoy a meal and hang out. Ambrose had great respect for the military and had a rule that when anyone in uniform walked in, students were required to give up their seats at the counter. A promotional picture requested by the bank shows Ambrose and his staff, with the banker kneeling in front and the windows full of servicemen. None of Ambrose's daughters are present in the photo because he wouldn't let them be photographed.

PHONE 5479

AMBROSE'S CAFE
120 N. EIGHTH STREET

CLEANLINESS ● QUALITY ● SERVICE

We Specialize in Eat Here If It Kills You—
Steaks and Chops We Need the Money

I have been in this business for 30 years. I have been pleasing and displeasing people ever since. I have made a lot of friends and a flock of enemies. I have been cussed and discussed, accused, talked and lied about. The only reason I am staying in this business is to see what in the hell will happen next.

AMBROSE HATHMAN

Ambrose Hathman's business card, front and back. *Collection of Ron Coleman.*

Gertie would make some of the breads but also buy some from a local bakery, and the meat all came from local farms. Some of the local favorites on the menu were the steak and eggs, liverwurst sandwich and hamburger with an egg on it. Diners could always expect to see three large glass jugs on the counter. One was filled with pickled pigs' feet, one with pickled eggs and one with pickles. If Ambrose deemed that a patron had had too much to drink and ordered another one, he would gesture to the three glass jars and order in his deep voice, "Pick your poison." The customer then had

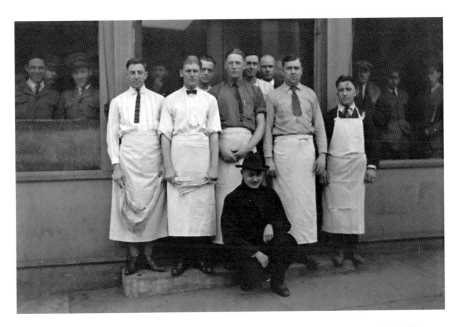

Ambrose's Café owner, staff and banker with soldiers in background. *Collection of Ron Coleman.*

to make a choice and eat something from one of the jars before he would be served another drink. Some made the choice, instead, to pass and make their way to the door.

Ambrose dedicated his life to his café. After many years of spending most of his waking hours within its walls, one day in 1957 he had a stroke and passed away in the café. His widow, Gertie, continued to run the café after his passing but, after a year and a half, made the decision to close it.

EVER EAT CAFÉ

One of the most legendary early 1900s cafés is the Ever Eat Café, located on a prime spot at 440 South Ninth Street, in between downtown and the University of Missouri campus. Bessie and Leonard "Huss" Morris and their son Ralph opened the Ever Eat in 1930. When Leonard died in 1938, Bessie and Ralph took over management of the café. The Morris family was no stranger to the food business in Columbia. The Model Café, Booche's Beer Parlor (later called Booche's Billiard Hall), the Virginia Café, Jim Morris

Café and OK Restaurant were all owned by either Leonard and Bessie Morris or one of Leonard's brothers. It seems the Morris family had a café dynasty in downtown Columbia!

The many articles written about the Ever Eat Café and Ralph Morris are testimony to the popularity of the café and the celebrity status of Ralph. Although the personality of the Morrises, as well as the customers, created a lively atmosphere in the Ever Eat, the appearance of the café was modest. Two rooms were split down the middle, with a beer parlor on one side and an eating area on the other. The restaurant side featured a horseshoe counter with sixteen stools on one side and fifteen on the other. The beer parlor had twelve to fourteen red booths plus four tables. The walls were bare except for a large picture of a tiger (the University of Missouri mascot). Ralph could be found behind the counter and Bessie behind the cash register, visiting with students. Ralph described his mother as "always a very pleasant lady, interested in talking to people. She always had a nice smile."

In an interview fifty years after the opening of Ever Eat, Ralph Morris talked about the food served at the café: "The Ever Eat was an old farmer's type place, with food that really stuck to your ribs like meat, bread and potatoes." Since the Ever Eat was open during the Great Depression and World War II, its low-priced but good food was a big draw for students and faculty alike. In the late 1930s, large glasses of milk or mugs of coffee were a nickel, slices of pie were a dime and donuts were two for a nickel. Plate lunches including meat, a vegetable, dessert, bread and butter *and* a drink had a whopping price of thirty-five cents. A pound of beef was stretched to ten small hamburgers that sold for a nickel each. A 1949 menu doesn't reflect much of an increase in prices; a hot steak sandwich with potatoes and gravy is listed for forty-five cents, homemade chili for twenty-five cents and a hamburger for twenty cents. The Roast Beef Plate, including bread, butter, coffee, potatoes and choice of two vegetables, could be enjoyed for sixty-five cents. Ralph said, "We had good, wholesome food, nothing fancy, with moderate prices. As a matter of fact, I think my biggest fault was that I was underpriced. I should have charged more; I gave more service than I should have for my prices."

Ralph and his mother, Bessie, had a reputation for going out of their way to help students who were short on money. Not only did they provide many students the opportunity to work at the café during their school years, but they also gave them meals on credit and loans of as much as seventy dollars. "It's easy to see how a kid can get into a fix," said Ralph. "Maybe it's just

Ralph Morris with a visiting mule team in front of the Ever Eat Café. *State Historical Society of Missouri.*

before Christmas, and that allowance from home has run out. So a guy will come in and say, 'Hey Ralph, lend me twenty bucks between now and January. When I get home, I'll put the bite on my dad.' And the thing is, the kid will pay you back that twenty bucks when the semester starts up again. You don't need IOUs with people like that." During the war, they received letters from New Guinea and Normandy with back money addressed to "Mom and Ralph Ever Eat."

Another way the Morrises helped students financially was the meal ticket program. Meal tickets cost $4.50 but gave ticket holders $5.00 worth of food. The price of the ticket was eventually raised to $5.00, but students who wanted a ticket and couldn't afford it at the time were allowed to charge the tickets. The meal tickets also helped Ralph and Bessie remember customers' names and build relationships with them. Students had to sign their names in a book so they would be able to eat if they lost their ticket. One notable meal ticket holder is former Missouri governor Warren Hearnes.

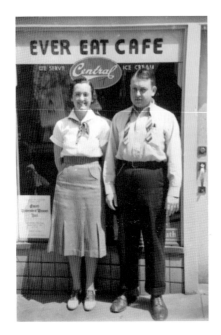

Ralph and Billie Morris in front of the Ever Eat Café. *State Historical Society of Missouri.*

Celebrity status was not limited to Columbia for Ralph and Bessie. "It's the darndest thing. I can be walking down the street in Kansas City or St. Louis, and all of a sudden somebody will say, 'Hi Ralph'—some kid that used to pay his board jerking sodas for me. Now he's a lawyer or doctor or something, but he has to stop me and hear the news from school, what the professors are doing and all. Gosh, sometimes I don't even remember the boy's name. Mom is the one with the good memory." Ralph was not the only one who called Bessie Mom. She served as a proxy mother to many of the students who considered the Ever Eat Café their home away from home.

The food was not the only draw to the Ever Eat for students. The beer parlor had a steady stream of loyal customers as well. Ralph Morris shared a memory about a Friday afternoon in 1933 shortly after Prohibition was repealed. Thirsty patrons had filled the Ever Eat, and it had almost run out of beer when a local brewery deliveryman showed up with twenty more cases of beer that hadn't yet been refrigerated. That didn't slow down sales. "I didn't even have time to cool it. I just started pulling caps and sold it hot," Morris said. "Beer was quite a novelty then.…Later on, when they had 3.2 percent beer, people would spike that with alcohol, but the two liquors didn't agree. It made you sick and drunk both."

In 1953, Bessie retired, leaving Ralph as the sole owner and manager. That same year, Alice "Billie" Hogan became his wife. In 1962, Ralph sold the restaurant, which made way for the also iconic Heidelberg restaurant (see chapter 10) in its spot.

THE SHACK

Located on the University of Missouri campus on Conley Avenue, across from Jesse Hall, was the Shack. It can be described as, well, a shack. It wasn't originally known as the Shack, but that was the name it had the longest and definitely the most well-known name of that student hangout. It began in 1921 as a house car owned by the Chandler Davis family, who served sandwiches to university students and faculty out if it. Maybe it was the first food truck in Columbia. Over time, it had slight additions, and by 1929, it was known as the Davis Tea Room and was a popular place for cheap jelly dates or just to grab a quick coffee or soda between classes or a beer after classes. During Prohibition, near beer was also on the menu. The Tea Room closed in 1933 for a few years and then was reopened as Jack's Shack. The name was eventually shortened to the Shack.

Due to its central location on campus, the Shack was a popular student hangout and also became the unofficial "office" of student Mort Walker in the late 1940s. Mort was the editor of *ShowMe*, a student-led school magazine. Mort Walker later created the Beetle Bailey comic strip with characters loosely based on his MU Kappa Sigma fraternity brothers. His first comic strip in 1950 featured his favorite college watering hole, the Shack.

Those who frequented the small restaurant in between similar-sized establishments along Conley Avenue still remember the "Shack Burger." Merle Wright, longtime patron of Columbia restaurants, credits the special sauce on the burgers to Mary Blackmore, who was one of the owners when it became Jack's Shack. She said she would take the recipe to the grave, but rumor is her son obtained the recipe and passed it along to the chefs at the University Alumni Center. The current chef said they had it at one time but didn't use it. An ad in the *Columbia Missourian* dated Friday, October 27, 1978, read "Hurry to the Shack for Good Times, Cold Beer, and the best damn Burgers in town" and "25¢ Beer Nite." This was appealing to college students as well as university faculty who didn't have to go far for a great burger and a beer after a long day in the classroom.

The Shack was also known for its booths and walls that were covered in carvings and graffiti from generations of visitors wanting to leave their marks to be looked for at their next visits. Melanie Carlson reminisced, "Nothing they open will ever compare to the vibe of the Shack. I think everybody who was ever there had their names carved somewhere. That was part of the charm; everybody left their mark." The Shack closed in 1984, and a fire in 1988 permanently removed the Shack. In its place is the driveway for the

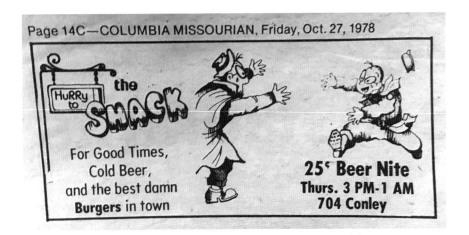

A 1978 ad for the Shack. *State Historical Society of Missouri.*

University Alumni Center. However, for those looking for a little nostalgia, you can still find some of the original tables that captured the names and sentiments of those who carved them in a replica of the Shack inside the MU Student Center.

WIG WAM CAFÉ

A popular café that was not located downtown was the Wig Wam Café, located on Highway U.S. 40. The cafe advertised "24 Hour Service—Catering to Good Food." The Native American–themed décor of the Wig Wam, including pottery, totem poles and cave-like walls, was like that of no other restaurant in Columbia. Proprietor Frank Fenton advertised on a postcard, "Everything to Eat from a Rattlesnake Sandwich to a 2 lb. Porterhouse Steak" and "Everything to Eat—(in season) at Popular Prices" "Liquor—No! Good Food—Yes!" Across the bottom of each side of the postcard was written, "Please do not read other side." This hints that Frank Fenton probably was a little bit ornery with a good-natured sense of humor. In 1948, a new postcard was sent (with a one-cent stamp) to Columbia residents announcing the new owners, the Nordinger Bros. It invited recipients to "Come, bring your family and friends. Enjoy one of our fine luncheons or dinners. Good courteous service."

The café didn't move, but the address changed to 904 East Business Loop 70 when Interstate 70 was built through Columbia in the early 1960s and rerouted cross-state travelers away from the café. By this time, the owner was James Flaspohler. Ken Gebhardt was the owner of other restaurants along the same U.S. 40 corridor and remembers Flaspohler contacting him and others to petition the state against carrying these customers away from them. It was an unsuccessful endeavor, and I70 was built north of U.S. 40. According to Gebhardt (known to locals as Poor Ken), this was an unexpected economic blessing. Within three months, business tripled as locals who had previously avoided the area now ventured north of town to see what they had been missing. Sadly, Flaspohler wasn't able to fully enjoy this additional business to his café. On January 15, 1966, he was shot to death at the age of thirty-six in an altercation on the back porch of a house behind the café. The manager of the Wig Wam, Elby Other Lasley, was the owner of the house and admitted to shooting his boss. Bob and Madge Pickett became the owners after that.

Despite the problems the owners faced, those who frequented it fondly remember the Wig Wam Café. Karlyn Henderson shared that she "used to go there with my parents to eat spaghetti. Their specialty. Loved it." John Wilke commented on a Facebook post about the Wig Wam, "The Wig-Wam

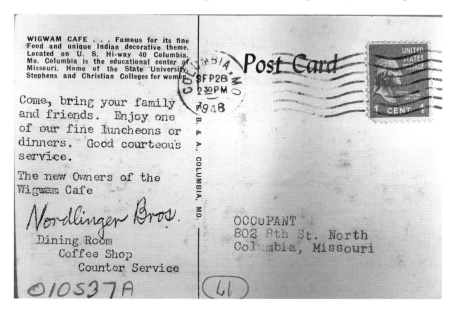

Wig Wam Café postcard. *State Historical Society of Missouri.*

was the official 'watering hole' for the Central Missouri Radio Squad a CB Radio club. In 1963, probably in effort to 'quench some thirsts,' the idea of the Boone County Volunteer Fire Department was conceived. As you may be aware, the idea succeeded and there are still some folks around continuing to deliver 'a helping hand.'" Wilke remembered not only the fellowship but also the food during the ownership of Jim Flaspohler. He continued, "I still remember how the centerpiece of the Friday spread was a carp. Actually quite good, just not advertised." The strip of buildings that included the Wig Wam has housed several different bars since then.

The 1940s through the 1960s

Serving a Growing Community

Columbia experienced large growth from the 1940s to the 1960s as the end of World War II brought many soldiers back home to the city, as well as to the University of Missouri to finish their education. These soldiers started families that contributed to a population growth, according to the U.S. Census, from 18,399 in 1940 to 36,650 in 1960. Interstate 70 was built on the north end of Columbia during this time, bringing more cross-state travelers through Columbia. Columbia was, and still is, the largest city between St. Louis and Kansas City, which made it a popular stop for travelers to rest and enjoy a meal.

To compete for this increased business, some restaurant owners came up with creative and unique ideas to get the seats filled in their places. One place, the Rollaway Café, arguably attracted too many people. The Rollaway Café was located on South Eighth Street, close to the University of Missouri campus, around the early 1960s. The main feature of this café was a large conveyor belt that went through the dining area and back into the kitchen. Customers would pay a flat price and then take a seat at the conveyor belt. As different food came out on the conveyer belt—a portion of roast beef, a bowl of green beans, a bowl of mashed potatoes, a roll—diners would take whatever they wanted. Customers loved it, and the owner deemed it a success. Word spread of the great concept, and the profits continued for the owner until news of the Rollaway reached the MU football players. The large football players brought their large appetites to the Rollaway, and profits took a hit. In addition, hungry and broke college students also found

their way to the Rollaway, along with containers that they could fill and stash in their pockets to enjoy later. This eventually led to the close of the Rollaway Café. It probably also made future restaurants that offered all-you-can-eat buffets very cautious in their pricing and policies about not leaving the premises with food!

A restaurant that fared better from its location on campus was the Italian Village. It was on Conley Avenue in the old location of Gaebler's Black & Gold Inn and on the same street as the Shack and Topic Café. It sold burgers and sandwiches but was known for its pizzas that were easy on the budget of college students. A small cheese pizza was $1.00 and a large sausage and cheese pizza was $1.50, and they flew out the door. At this time, the college dorms didn't serve meals on Sundays, so it was typical for Sunday to be a very busy day for the Italian Village. According to Merle Wright, a former owner, "Ninety percent of the business was from college students except if it was a football game day. On home football game days, 99 percent of the business was from alumni wanting a 'taste' of their college days." One of the managers of the Italian Village was Dick Walls, who would later go on to own the Heidelberg, the Hofbrau House, Smokehouse BBQ and Boone Tavern restaurants.

The college students were not the only restaurant customers in Columbia, and other dining establishments had great success and created memorable dining experiences for locals as well as visitors.

BREISCH'S

In 1956, a young couple living in St. Louis recognized the potential of a bankrupted Columbia restaurant located in a prime location in the downtown area. Leroy and Nellie Watkins seized the opportunity and in a short amount of time turned Breisch's, on the corner of Ninth and Locust Streets, into one of Columbia's favorite restaurants and a very busy catering operation too. It was divided into two distinct eating areas. The coffee shop sat 32 diners at a U-shaped counter, and the more formal dining room had table seating for 144 guests. Leroy and Nellie trained their children in different areas of the restaurant operation. Their son Bob started training in the kitchen and eventually became head chef. Daughter Bonnie was trained in the front of the restaurant with the hostess duties from the age of seventeen.

Nellie and Leroy Watkins with children Bob and Bonnie. *Collection of the Watkins family.*

Leroy and Nellie worked with Chef Rothie Nichols to create menus that were designed to meet the demands and tastes of college students, their parents, faculty and business and professional people who were well traveled. They didn't have a business plan of being the cheapest place to get a meal, but instead, it was their goal to provide high-quality food with distinctive service. To ensure the highest levels of service were achieved, they sent several waitresses to Custer McDonald's fine Waitress Training Courses and then had those who attended train the rest of the staff. Nellie had studied home economics at the University of Missouri and made sure the atmosphere of Breisch's was always appealing, with fresh flowers, white tablecloths and soft lighting. She could usually be found at the cashier's desk, where she could keep a watchful eye over both sides of the restaurant.

Bob Watkins remembers his dad as "quite a showman" and says he was always looking for ways to promote the restaurant, either through relationships built through community involvement or providing memorable dining experiences in the restaurant. In the 1960s, Tuesdays and Thursdays were slow, so Leroy came up with the idea of all-you-can-eat nights. Tuesdays were spaghetti for two dollars, and Thursdays were two dollars for all the fried chicken and sides you could eat. Word spread quickly, and in no time, the restaurant was packed on those nights. Leroy then added a steak and seafood night for three dollars per person. He believed that a nice meal out should be an experience. On weekends, there was frequently a live broadcast from the dining room on a local radio show that featured music from a Hammond organ and guest interviews. Lou Washington lived in Columbia during that time and wrote, "Post Sunday school cinnamon rolls at Breisch's were a family tradition! KFRU would broadcast from there on certain nights. I also recall live music on a Hammond organ." On some Friday nights, they would stage a fashion show using college girls to model the latest designs provided by two well-known dress shops in the downtown area.

The Watkinses were very involved with various community groups and volunteered the use of their restaurant on many occasions. The Cosmopolitan Club, a local men's group at the time, held its annual Pancake Day fundraiser at Breisch's every year until it closed. Longtime Columbia local Sally Phillips, whose dad was a Cosmo Club member, remembers, "It was a big deal every year, and all members and some wives and children worked serving pancakes."

Breisch's was a fun place to visit, but it was also well known for its food. Bob Watkins remembers having a butcher area in the back of the restaurant where they would cut their own steaks. Everything from the

Leroy Watkins inspecting cinnamon rolls with Chef Wiley Davis in Breisch's kitchen. *Collection of the Watkins family.*

salad dressing to the dinner rolls to the famous cinnamon rolls was made from scratch. The original owners, the Breisches, were German, and they passed along some of their recipes, but many of the recipes were ones that Leroy added over time. Locals and those who lived in Columbia at the time have fond memories of both the atmosphere and the food. Janet Swope wrote, "Fabulous food and always felt so special when we got to go eat there." Lou Washington remembered some of the new foods he was exposed to there: "They introduced me to such delights as smoke [*sic*] oysters and creamed pickled herring!!"

With their proximity to the university campus and their reputation for delicious and high-quality food, the Watkinses and Chef Nichols were frequently catering events for the university. One of the most memorable was a School of Journalism banquet. It was held at Brewer Field House for seven hundred guests, with all the finest foods served on china. That was an "all hands on deck" event!

When Leroy and Nellie purchased Breisch's, Columbia had a carry-in law. Customers could bring their own liquor to restaurants that had a carry-in license, and then the restaurant could provide the setup to the guest. Many credit Leroy's efforts in working with the city to get this law changed in 1968 to allow restaurants in Columbia to sell alcohol in a drink.

Mr. and Mrs. Watson ran Breisch's successfully for over fifteen years until 1972, when Leroy passed away.

The northeast corner of Ninth and Locust Streets has been home to restaurants, clothing stores and now a student housing apartment complex. However, for many who were around Columbia during the 1960s, it will always be best remembered as the home of Breisch's.

GLENN'S CAFÉ

Perhaps no other restaurant in Columbia has seen the complete change of its menu, decor and concept as many times as Glenn's Café. It has been a New Orleans–style restaurant, moved to a new city as a hotel restaurant and was brought back to Columbia as a nice hotel restaurant with Cajun and southern comfort influences, but before all those incarnations, it was a small diner on Highway 40 that had a loyal following for over forty years. A lit framed picture of the original café is displayed in a prominent spot in the current Glenn's Café, which is now located in the historic Tiger Hotel and owned by Glyn Laverick. The original café was opened around 1939 by Glenn Purdy and his wife, Tilley, as a combination diner/gas station. It was eventually bought by Rolla Williams and continued its run in the same location.

There are many stories about the kindness and "homey" feel of the diner under the Purdys and Rolla Williams. Joe Newberry remembered, "My mother, Virginia Newberry, was ill for many years, and she and my dad would go to Glenn's a few times a week for supper. Rolla always treated her like a queen and would fix her things that weren't even on the menu.…He'd just say, 'Virginia, what sounds good to you?' I'll never forget his kindness." Denise Kay Schoennoehl wrote, "Loved going to Glenn's Café when we were growing up. Excellent food and one of the few places where my dad wanted to go for dinner. He was a foodie and was very selective about his restaurant choices."

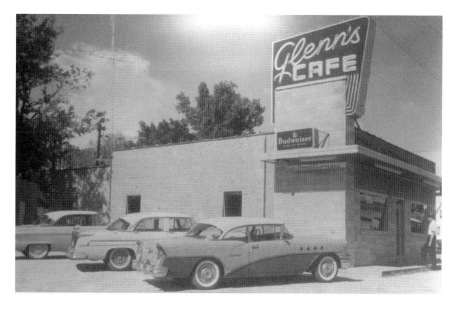

A picture of the original Glenn's Café on display at the Tiger Hotel Glenn's Café. *Author's collection.*

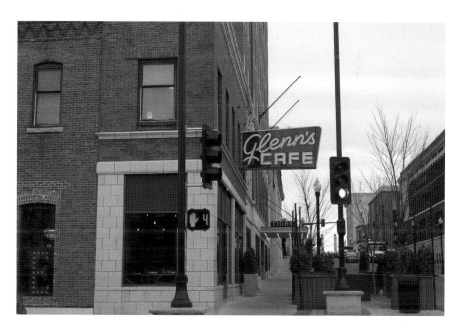

Glenn's Café in the Tiger Hotel with original 1939 sign. *Author's collection.*

Glenn's was located close to the cancer hospital, so many of its customers were patients and families grabbing a bite to eat before or after an appointment. Cathy Sappington's mother was from nearby Mexico, Missouri, and would come to Columbia for her cancer treatments. Cathy always suggested different restaurants for her to visit after each appointment, but her mom always insisted on returning to Glenn's Café. "Her favorite food was their beans and cornbread with lots of onions on the side. It became so routine, the wait staff knew us each week when we entered and always brought her the beans and onions. Oh, those memories."

In the mid-1980s, it was purchased by Steve Cupp and moved downtown, with the original sign, to the corner of Ninth and Cherry. The menu was changed to New Orleans style. Glenn's Café moved two more times before settling in its current home in the Tiger Hotel. The original sign (now displayed on Eighth Street outside the Tiger Hotel) and a black-and-white picture of the little diner on the new Glenn's Café's wall are all that remain of the original little diner.

CLARK'S SODA LUNCHEONETTE

Along Broadway, in the year 1955, Boone County native Fred Clark opened Clark's Soda Luncheonette. He had previously successfully operated a soda fountain and lunch counter in the middle of Hopper-Pollard Drug Store. When he saw that the storefront in between Kennedy's Town & Country Men's Wear and Jimmy Proctor's Real Estate was becoming available right on the main road through downtown, he jumped on the chance to open his own place. Many of the locals, especially those who worked in the downtown area, were already familiar with Fred from his time at the drugstore, so he had an instant customer base when he opened. Sondra Howe, Fred's daughter, shared her memories of Clark's and her father. Fred was easily recognizable, as he was always wearing a freshly starched white long-sleeved shirt and pants, apron, bow tie and a white paper "soda jerk" hat.

The luncheonette was open six days a week for breakfast, lunch and dinner. Clark's was known for its ham salad, chicken salad, pimento cheese and potato salad that was made fresh daily. It was also a popular hangout for high school students who would descend upon Clark's after school for fresh-squeezed lemonade, limeade or orangeade with a scoop of sherbet. Others would order a marshmallow Coke or chocolate Coke. Marjorie Barnes

Marberry remembers she "walked from Hickman [high school] and had a fresh squeezed Orangeade and fries every day after school with my besties."

Diane Maxwell wrote:

> *That was the first place where I ate lunch when I came with my parents to look for a place to live. The year was 1958 and I was five. I distinctly remembered the name was Clark's and I distinctly remembered the lunch counter. We moved from St. Louis where soda meant Coca Cola, Pepsi Cola, 7-Up, etc. When I said I wanted a soda, the woman waiting on us asked what kind of ice cream I wanted. I was SO confused. My mom explained I wanted a Coca Cola. The waitperson responded with, "Oh you mean pop." I had never heard of soda being called pop until that day.*

Home football games kept Fred Clark extra busy. In addition to the extra crowds at the luncheonette, Fred delivered his sandwiches and famous chili to the Mizzou press box. Clark's also had a loyal following from a group of downtown business owners who would meet regularly at 9:30 a.m. and 4:30 p.m. every day. Some of those businessmen are still around and well known to locals—Leo Van Courten, Phil Prather, Sid Neate, Gene Glenn, Ken Puckett and Warren Dalton. Fred enjoyed hosting this group and giving them trouble whenever he had the opportunity. A sign on the wall of the luncheonette with the title "This restaurant recommended by the following individuals and organizations" showed that Fred didn't take himself too seriously. The "organizations" that recommended him were all

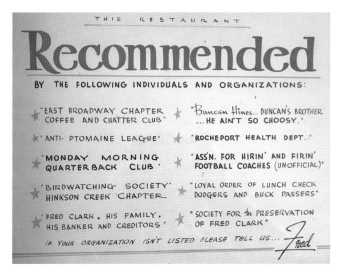

Sign hanging on the wall of Clark's Soda Luncheonette. *Collection of the Fred Clark family.*

made-up groups that referred to topics that locals would understand. One of those organizations was a reference to the group of business owners he hosted twice daily, the "East Broadway Chapter /Coffee and Chatter Club." Fred decided to sell the café in 1967 and went to work for Stephens College food service.

PLA-BOY DRIVE-IN, DOG N SUDS DRIVE-IN AND O-BOY DRIVE-IN

The trifecta of drive-ins Pla-Boy, Dog n Suds and O-Boy along U.S. 40, later called Business Loop 70, can all be credited to brothers Ken and Del Gebhardt. The Gebhardt brothers are better known as Poor Ken and Lonesome Del to Columbians who have been around for several decades. Ken's wife, Martha, also played an active role in the restaurants while working a full-time job at the University of Missouri. The three drive-ins actually consisted of two locations: Pla-Boy was one block east of Hickman High School, and Dog n Suds, later becoming O-Boy Drive-in, was one block to the west.

In 1955, after getting out of the army, Ken Gebhardt attended the University of Missouri as an agriculture student. To earn money while attending school, he took a job, along with his brother Del, as a carhop for twenty cents an hour at Pla-Boy Drive-In. Within weeks, Ken and Del were the owners, and their adventures as restaurant owners and entrepreneurs had begun. Ken quit school to devote all his time and efforts to the drive-in. They sold Pla-Boy in 1957 and opened a Dog n Suds franchise down the road, where five-cent root beers and fifteen-cent hot dogs were popular on the menu. After the owners attended a franchise meeting, they realized that their drive-in was performing well above the others and attributed it to their management. So after a year of operating the Dog n Suds, they dropped the franchise and changed the name to O-Boy. In the mid-1960s, Pla-Boy went bankrupt, and the Gebhardts bought it back. Ron Coleman, who would later manage another of Poor Ken and Lonesome Del's restaurants, remembered being mischievous as a teenager. He said, "They would run us off from one drive-in, and we'd just go to the other."

The food was basically the same as every drive-in, with the standard offerings of burgers, hot dogs, triple-decker sandwiches, grilled cheese sandwiches and, of course, malts and shakes. Poor Ken and Lonesome

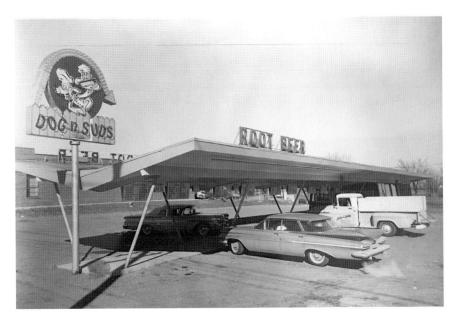

Dog n Suds Drive-In. *Collection of the Gebhardt family.*

Del had their own twists to the recipes, but the management and the "unusual promotions" that were the brainchild of the Gebhardt brothers were probably what put them on the map. Mark Brunstrom, who attended Hickman High School, remembered the atmosphere and the food of Pla-Boy fondly: "When I was a teenager, that was a gathering place for a lot of us. Most Friday and Saturday nights started with Pla-Boy Drive-In. Several cruise throughs and the infamous Pla-Boy burger. I wish I had the recipe!" Ron Knudsen's memories of Pla-Boy and Dog n Suds revolve around cars. He shared, "When in high school at Hickman during the years '57–'59 the Pla-Boy was the 'go-to' place…during school hours and evenings both." When asked about a comment he made on social media about driving through a window at the Pla-Boy, Ron responded:

The story about the broken window probably needs a little explanation so you don't think my friend Dick Miller and I were a couple of ornery kids causing trouble (but we did cause the Pla-Boy to close on a very busy night). My friend was driving his old beat-up '49 Ford convertible and when backing out of a parking space at the side of the parking area, and towards the big glass windows surrounding the inside dining area, he could not see out the rear window. He opened his door to see where he was going,

and it looked like he had about 15 feet…but because of the shape of the building, when I looked out the passenger side, I could tell he only had about 5 feet.…I hollered at him. But it was too late! He had already backed through 2 of the big windows, hit the jukebox and sent customers running. Nobody was hurt, but it was a really cold night so the customers all left pretty quickly and the manager closed the business for the night.

Ron Knudsen worked for about a year at Dog n Suds and remembers that Ken and Del "both had great, friendly personalities which made them great to work for and allowed them to make a tremendous number of friends and customers in their business ventures." Ron also remembers some fun with cars that he used to have with Del: "I had a '55 Ford at that time and it ran well and fast but it was no match for Del's 'factory hot rod' Chevy convertible with huge engine and 4-speed floor shift. But I was Ford…he was Chevy, so I could often get him to go to south Providence Road where there was very little traffic by the time that we closed the drive-in…and we would have a 'friendly' drag race. Del always won but it was fun anyway."

With a twinkle in his eye and a wide grin, Ken Gebhardt told the story of one of the most famous promotions of the Gebhardt brothers. Ken and Del decided to set out to break a Guinness world record for someone staying the longest on top of a flagpole. Ken built a five-by-seven shelter and hoisted it thirty feet to the top of a flagpole in the parking lot of O-Boy. This was no small feat! After live broadcasting the 1959 university homecoming parade, the local KBIA radio broadcaster made his way to O-Boy to attempt to break the world record of three and a half months of flagpole sitting. His afternoon radio show was broadcast every day from his position atop the flagpole. You might ask what that has to do with a restaurant. Well, Ken and Del knew that all the carloads of people driving to see the sight where the record breaking was being attempted would get hungry and thirsty, so they might as well pull in and place an order. O-Boy also enjoyed the publicity from the live radio show. Unfortunately, after twenty-eight days of flagpole sitting, the disc jockey got sick (or maybe just sick of flagpole sitting) and left his perch in the middle of the night. Ken and Del weren't ready to give up on the buzz being created by the record-breaking attempt, and the disc jockey continued to call in his show but pretend it was from the shelter. When cars below made demands for his appearance, he just said that he was too sick to come out. The stunt didn't last long, and a new record wasn't made, but at least all the radio listeners now knew where O-Boy was!

Poor Ken and Lonesome Del had some concern when McDonald's moved in close by. It was a new concept in Columbia, and they didn't know how it would affect their business. The consensus between the brothers was that after a few months, the newness wore off, and the new restaurant actually brought more business their way. Poor Ken and Lonesome Del also had other restaurants, including Gebhardt's Barbecue and the Interstate Pancake Howse. By 1980, they had sold the drive-ins and were focusing on other business interests including the Interstate Pancake Howse that benefited from being open twenty-four hours and had great visibility from Interstate 70 and more unusual promotions.

THE BULL PEN CAFÉ

A livestock sale barn became the impetus for a one-of-a-kind restaurant on the outskirts of Columbia. In 1944, George Smarr moved his livestock barn and auction business to what is now known as Business Loop 70, very close to the highway. This location was outside Columbia's city limits and out of reach of any city regulations.

In 1950, C.S. "Shorty" Danley saw a need and an opportunity for a profitable restaurant to serve those selling and buying at the livestock auctions. Shorty already had restaurant experience as the owner of the Topic Café, which was on the MU campus. A deal was made with the sale barn owner that Shorty didn't have to pay rent but he had to stay open until the last sale of the day was over. On some busy sale days, the café would still be serving customers past midnight. Shorty's son Milt took over the restaurant until his death in 1981. By that time, Helen Lane had led the serving staff for several years and made the decision to purchase the restaurant. From that day forward, the ownership of the Bull Pen Café would remain in Helen's family. Helen hired her nieces Jackie Cockrell and Debbie McFarland as waitresses. When Helen died in 1991, Jackie considered the Bull Pen customers and staff her family; some literally were. She saw how hard her Aunt Helen had worked to keep the Bull Pen Café running, and she wanted to keep it going. So with four of the regular customers—Billy Boyce Sr., Billy Boyce Jr., Charlie Bell and Marvin Boyce—Jackie, who had been working at the café since she was seventeen, became an owner in the place that was so dear to her. A year later, she bought out the other partners and became the sole owner. The first year was especially hard for Jackie because

her only experience with the restaurant was as a waitress. She had a lot to learn about being an owner, but with the support of the staff and the regular customers, she continued the success of the Bull Pen.

In a short amount of time spent with Jackie as she reflected about her time at the Bull Pen Café, it quickly became evident how dear everything about the unassuming café with the black-and-white cow-print walls was to her. Just as most people collect pictures and newspaper clippings about their families, Jackie has a scrapbook and multiple photo albums containing her memories of her Bull Pen Café "family." As she slowly flipped through the pages, taking it all in, Jackie said, "It was home-cooked meals, breakfast all day. Everyone was like family." She smiled as she remembered all the celebrations that took place at the Bull Pen. There were baptism dinners, baby showers, birthday parties, Thanksgiving dinners with longtime regulars and anyone else who wanted to join in and anniversary celebrations. Just like in families, the nicknames of staff and customers were many and held special stories to go along with each one. Jackie was "Papoose" from when she was a young mom waiting tables with her newborn daughter in a carrier on her back. The staff and customers had names including Nuts, Bubba, Cracker, Alf, Pucker Lips, Breadman, Sledge, Flash, Baby Jo, Golden Arches and Crash, and yes, there are funny stories behind all the names. Without having to even stop and think about it, Jackie can rattle off the names of all the employees: "Debbi Hartmann was our dishwasher; the cooks were Dusty Cohee, Carl Covington, Darren Tharp, Bobbie Jo Cockrell and Tamica Cockrell [the newborn who earned Jackie her nickname]. The waitresses were my girls! Christie McCaleb [Helen's granddaughter], Debbie MacFarland, Karen Herigon, Sandy Barnhart and Pam Swam made up the wait staff." When asked about who the typical customer was at the Bull Pen, Jackie said, "We had all types—construction workers, doctors, lawyers, farmers, business owners. Politics sometimes caused some heated discussions! People would come in covered in mud or dressed in a suit and tie, and both felt comfortable. We fussed over all of them."

There were the local regulars and the sale barn regulars. The local regulars included a group of men who often had pitch games at the café. Theresa Howe, whose dad, Joe Carpenter, was one of the regulars, shared her memories about the Bull Pen Café and "some of the most caring, gruff men" she's ever known. Theresa wrote:

The girls were great. They didn't take much bull off the men around there and worked their cans off. More deals over handshakes than you can ever

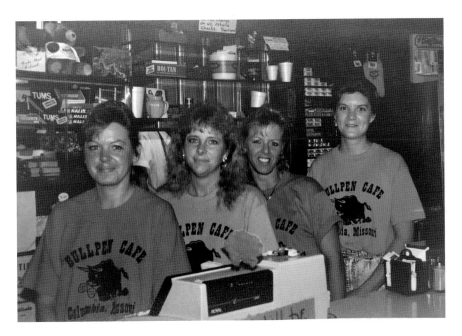

Left to right: Debbie McFarland, Jackie Cockrell (owner), Karen Herigon and Debbi Hartmann at the Bull Pen Cafe. *Collection of Jackie Cockrell.*

imagine. That was the "old timers" of Boone County's hangout. Possibly had more cards than Vegas on some days. Gentlemanly bets of course, where each of the men would collect from the "rollers" for whatever was the cause. Billy Boyce was usually collecting for the Kids of Columbia Christmas program, with Bruce Wilson, Mike Teel and Joe Carpenter to shame the "tightwads" into handing over cash. Ladies just didn't want to go on cattle selling day—PU!

Becky Rees-Westling's grandparents were regulars too. She remembers, "Growing up my grandparents took me to the Bull Pen every Friday. I had hamburger, coke, and French fries. As I grew up, on Wednesdays I would drive by and see Grampy's truck there and go in and eat with him and my uncle. I would just 'happen to be going by' and got a free meal!"

There was the time when two of the regulars, who were both over eighty years old, started arguing about who was a faster runner. Neither Billy Boyce nor Gordon Burnam was the type of man who would back down, so a footrace was scheduled to determine the winner of the argument. The race was set to take place in the Bull Pen parking lot, and their friends placed bets on who would win. Race day came, and a large crowd gathered to

witness the event. Billy rolled up his pants and paraded around with a box of Wheaties cereal to get the crowd pumped up. Ready, set, go! The runners were off, and Gordon fell while Billy kept going to the finish line. Billy Boyce declared himself the winner, and Jackie declared the race a good one since neither runner left with serious injuries.

Jackie and her employees had close relationships with those who regularly attended the livestock sales, as well as the auctioneers. They wanted to help sale barn owner and auctioneer Luther Angell celebrate his birthday. Waitress Debbie MacFarland had the important task of carrying the cake into the ring so the crowd could sing to him. One step in the ring and the cake fell off the tray and right onto the floor of the auction ring where livestock had been paraded all day. Luther didn't want Debbie to feel bad, so without missing a beat, he bent over, picked up the cake and took a bite!

In addition to the regular types of foods that you would expect at a café like roast beef, mashed potatoes and gravy, as well as breakfast foods, there were a couple of unique things that not everyone would order. No conversation among those who ate at the Bull Pen can occur without the mention of scrambled brains and eggs and brain sandwiches! The menu and recipes changed over time, but a lot of Helen's original recipes were continued. Bobbi JoJo's Special Mess (eggs, hash browns, peppers, onions, mushrooms, bacon and cheese), named after one of Jackie's daughters and the creator of the dish, quickly became a favorite. Plenty of breaded tenderloin sandwiches and Bull Burgers were ordered too. Jackie remembers everyone raving over her made-from-scratch bread pudding, which included doughnuts that she would make just for the bread pudding.

One of the regulars, Bill Burnett, owns the outdoor equipment store down the road from the Bull Pen. When asked what his favorite thing on the menu was, he immediately said, "Always breakfast!" Bill remembers the Bull Pen Café as a special place full of special people. He said he would go there all the time because "it was close and because of all the other people that went there.…Everybody landed there, and you couldn't get a seat at lunch time. The sale barn helped, but all the old-timers would always show up. Jackie and Debbie were great." Bill said some of his favorite memories of the Bull Pen revolve around pitch. "Always had our card games. Pitch almost every day in the Blue Room, and it closed for a pitch tournament once a year."

It is clear that the Bull Pen Café had a loyal following of those who went there for the fellowship and sense of family as much as they did for the home-cooked meals. Situations outside of Jackie's control took a toll on her

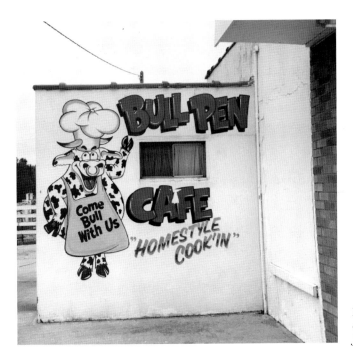

Bull Pen Café exterior. *Collection of Jackie Cockrell.*

business. Interstate 70 went through an extensive construction project, which changed the exits and made it very cumbersome for people to get to the Bull Pen. In 2003, the sale barn closed. Lastly, the City of Columbia passed a smoking ban at restaurants, and by this time, the city limits had stretched to include the location of the Bull Pen Café. After twenty-nine years of working at and owning the Bull Pen Café, Jackie made the heartbreaking decision to close the Columbia landmark in 2007. Ten years later, Bill Clark, a local historian, wrote in his column in the *Columbia Daily Tribune* on Friday, March 24, 2017, "Bandy Jacobs, the teenage auctioneer who joined his dad to open the sale barn, ate the first breakfast on Day One of the Bull Pen and the last lunch on March 31, 2007."

Jackie wrote a "Bull Pen Farewell" to her customers:

Not only has our family grown, but we have been fortunate to have been adopted by many of you. We have attended your weddings, birthday parties and funerals. Our customers have many, many times become our friends and we are grateful. We will miss each one of you. Pleasant memories include foot races in the parking lot, the old goats vs. the young nannies softball games, card games, quarter flipping and the numbers game. Pitch parties, holiday buffets, BBQ specials and brain sandwiches

also foster great memories. Crown and Coke, Jell-O Shots and Bud Light wrapped up many a harried day. There will be no more football pots, play off brackets or Lotto pools. And thank goodness we will not have to endure any more politicians!

She ended her letter with this sentiment: "Finally, remember this was not Burger King—you got it our way and if you did not cotton to that, then Bobby Jo would cheerily show you to the door. In all seriousness though, I guess this brings us to the hard part—good-bye. It's sad and we do not know what the future holds but we do know that the many friends we have made will not forget us."

An auction was held so customers had the opportunity to purchase memorabilia from their favorite restaurant. Jackie kept a few things she couldn't part with, the Columbia Historic Preservation Commission gathered some historical items and then the building was bulldozed. An empty lot remains where for fifty-seven years many meals were enjoyed and many memories were made.

CHAPTER 7

The Sharp End

Columbia's Black Business Community

From the early 1900s to the 1960s, the Sharp End business district was a city within a city for Columbia's black community. Stretching from Fifth to Sixth streets on both sides of Walnut Street, Sharp End was a robust business center with black-owned restaurants, meeting halls, barbershops, bars and more." This is how a metal plaque that stands at the original location of the Sharp End begins its description of the once thriving black business district at the north edge of the downtown area.

The Sharp End existed as a result of segregation in Columbia. Sehon Williams, a local black man born in 1922, with a sharp-as-a-tack memory, remembers the Sharp End well. He shared his stories in a personal interview. He remembers the invisible boundaries: "There was no reason to go south of Broadway unless you were working there." Many businesses did not welcome blacks, and Columbia restaurants would not serve them. Sehon also said, "If your wife went downtown to buy a hat, she had to let the store clerk try it on. She couldn't try it on. And if she bought a dress, she couldn't try it on or it was used goods." This is the environment that created the need for a business district like the Sharp End.

At the turn of the century, the black population was increasingly moving to the city from rural areas. The 1910 census recorded that, for the first time, more than half of Boone County's black population lived within the city limits. Since the Civil War, the number of black residents living in the city had grown from 541 to more than 2,200. Small communities developed in areas just on the outside of the city center at the time, and in response,

black-owned businesses started opening in the area that would be known as the Sharp End. One of the first recorded businesses in the Sharp End area was a lunch counter owned by Perry Bones (according to the 1910 census) or Perry Bowen (according to a 1909 city directory). He ran the lunch counter out of the home he owned mortgage-free.

A specific origin for the name "Sharp End" isn't documented or unanimously agreed upon. Three main theories have been written about over time. One is that it is named after an unnamed street at the intersection where St. Luke's Church was located that was often referred to as Sharp Avenue. There are some historical inaccuracies that make this theory doubtful. A second theory is that the name refers to the dress of the people who frequented the Sharp End. The women wore dresses, and men wore suits and ties. Ed Tibbs is the owner of a historic building on the corner of Walnut and Fifth Streets that remains from the Sharp End District. Ed Tibbs's father, Ed "Dick" Tibbs, bought the building in 1943, and Ed inherited it upon his death. Ed remembers his father as a man who always dressed well. "My dad, I had never seen my dad without a tie on. My dad almost always had a tie on, white shirt and tie, throughout my entire life. I just thought that is the way you are supposed to be dressed." The third theory is that it was a dangerous place and the name refers to the knives and razors that were carried by those who spent time in the area. Sehon Williams agrees with this theory and says it was a dangerous area and known as such across the country. He witnessed knives and switchblades appearing out of nowhere if things got too heated, usually over a woman. Sehon remembers that that was not exclusive to just the Sharp End; Eighth Street was the equivalent for white people with knives and razors. Sehon served in Italy during World War II in the Buffalo Division. When he was in the army, he remembers meeting a soldier who was from Philadelphia. As soon as the soldier learned Sehon was from Columbia, Missouri, he said, "That's where they cut people."

A strict age limit of eighteen was enforced before you could go in the Sharp End. There was also a code of no unescorted women. Boys could play pool after they turned sixteen if their parents gave permission, but young girls could not enter the pool hall.

The Sharp End is referred to as a business district, but Sehon Williams says, "It was not a business area; it was a social area." It was where people gathered after work. Due to the age limits and potentially dangerous activity if things got out of hand, 80 percent of people in the black community, according to Sehon, socialized at church or on one another's front porches.

However, if someone was looking for a fun night of drinking, dancing and listening to great music, the Sharp End is where they went. One of the most popular places of its time was the Green Tea Tavern, where Sehon Williams played trumpet with the house band in the early 1940s. Sehon remembers playing with the drummer Rudolph "Rudy" Pitts in the band. Rudy was a born and raised Columbian who went on to play in bands all across the country. Alvin Coleman and Dick Tibbs operated the Green Tea Tavern. When the bands weren't playing, the jukeboxes were. Meryl Wright owned a coin-operated machine business that included jukeboxes. One night at midnight, he was called to one of the dance spots in the Sharp End because the jukebox was broken. It wouldn't let anyone put quarters in it. Meryl showed up, hoping the late-night repair wouldn't be a long one. He opened up the machine to see what the problem was and happily discovered it wasn't broken at all. No one could get a quarter in because it was completely full of quarters! An easy fix, and the music and dancing were able to continue into the night.

During the sixty-plus years of the Sharp End, many restaurants and cafés operated and became gathering places within the area. George Scott opened one of the first recorded restaurants, with an address of 15 North Sixth Street in the 1917 city directory. However, there were earlier businesses that took care of black residents' needs for services that could not be obtained in other parts of Columbia. These weren't recognized in the city directories, but several provided food service out of their private homes. Other restaurants listed over the years included the Dreamland Café operated by Maggie Brown in the 1920s, Coleman's Café operated by Harry Coleman in the 1930s, O'Neal's Lunch operated by Addie O'Neal in the 1940s, Walnut Grill operated by David "Pig" Emory in the 1940s and several restaurants that were just listed as "Walnut—Restaurant" with the owner's name. Some of the more recent restaurants' stories are still passed along from the current Columbia residents who have personal memories associated with those places.

ELITE CAFÉ

The Elite Café had an address of 520 Walnut (where the current Sharp End historical marker is located) and listed Robert, age thirty-six, and Edna Harris, age thirty-eight, as the owners in the 1949 directory. In the 1940

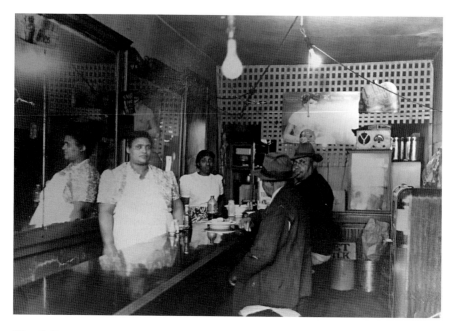

Elite Café owner Edna Harris (*far left*) in the late 1940s. *State Historical Society of Missouri.*

census, Robert was listed as a dishwasher who earned $360 for thirty-six weeks' work at a women's college, presumably Stephens College. Edna earned $500 for the year 1939 and was listed as a laundress. By the time the 1951 directory was printed, the Elite Café was owned by Lawrence E. Lee. Sehon Williams remembers the Elite Café under the ownership of Lee and said, "He made the best fried chicken!" When asked what else was on the menu, Sehon said, "All the cafés served soul food—fried chicken, pigs' feet, navy beans, greens, pies and cakes."

VI'S CAFÉ

Apparently 509 Walnut was a popular spot for cafés! In the 1930s, Beulah King owned a restaurant at that location. Arlene Brown was listed as the operator of a restaurant there in 1940, Leonard Smith operated a restaurant there in 1947, David "Pig" Emory operated the Walnut Grill in the same spot. By the late 1950s, it had become Vi's Café, operated by Vitilla Monroe. Her daughter Erma Officer shared her memories in an extensive booklet

written by Rudi Keller and printed by the *Columbia Daily Tribune* in 2015. Erma remembers being awakened early every morning by her mother so they could be at the restaurant by 5:30 a.m. to prepare for opening the door for customers at 6:30 a.m. At that time of day, black city employees on their way to work were regular customers. Erma would work in the café for an hour and then walk to Douglass School, the school for black students, three blocks away. She was quoted as saying, "It was busy every hour my mother was open." After school and any extracurricular activities, Erma would walk back to the café, do her homework and help out at the restaurant until it closed at 7:00 p.m. On weekends, Vi's Café stayed open until 1:00 a.m. Erma Officer credits her mother with teaching her business skills and how to treat others, not expecting any more than she was willing to give.

In Vitilla's family, everyone pitched in. Her niece Cheryl Ballenger Wright also worked in the café. She remembered, "Sometimes she had me being a waitress, and I had tips." The café was set up like most others, with barstools at a counter, tables and a room set up for families, but Cheryl remembers food being the attraction. Some of the foods that Cheryl remembered were cornbread, chicken, greens, dried beans, navy beans, brown beans, different pastries, pies, bread pudding, roast beef and ham on occasion.

THE WAYSIDE INN — ANNIE FISHER

Out in the country was a "chicken-dinner" place called Wayside Inn. It is a notable restaurant but not located within the Sharp End. However, its owner, Annie Fisher, owned several homes around the Sharp End area and within the black community, as well as what was considered a "white only" area. Several writings exist about this remarkable and successful black woman who can be considered a pioneer of her time, and her story is one that should be shared. She became famous for her "beaten biscuits," but her legacy is much more encompassing than "an ordinary biscuit baked while the life is in it," as Annie Fisher described her famous biscuits to a reporter in 1927.

Annie was born in 1867, one of eleven children of former slaves who lived in the Columbia area, and went on to accumulate eighteen rental homes and two mansions from her profits catering and selling her beaten biscuits before her death in 1938. One of her mansions was a fourteen-room home a few blocks away from the Sharp End, at 608 Park Avenue. It was later used as a funeral home. Although nothing was wrong with it, the house was

demolished as part of the city's 1958 urban renewal plan. Her real estate properties are a story by themselves, but her catering and marketing skills are what first made her wealthy and famous.

By 1927, Annie Fisher had been Columbia's premier caterer for twenty-five years. Each catered meal featured the beaten biscuit. She also sold them through mail order for ten to fifteen cents per dozen. Her biscuits were in high demand, and in 1911, a Sedalia hostess even served them at a dinner for President William Taft when he visited the Sedalia State Fair. Historian Mary Beth Brown researched Annie Fisher and shared some of her information with the Sharp End Heritage Committee. Brown shared a quote she found in a self-published autobiography of Frank Nifong, a physician at the time and still a recognizable name in Columbia. Dr. Nifong referred to Annie Fisher as "the most efficient cateress in the town of Columbia and that no university or social function was really classy without her service."

In 1919, she told an audience that she had served an alumni dinner at the University of Missouri, receiving $1,200 for the meal. She also shared that when she did not have enough table settings, "they would always be kind enough to let me use their silverware." In 1908, A. Ross Hill took over as the university president. Annie Fisher had a catering job for a very large university banquet, but the new president wouldn't let her have the use of their silverware, saying it belonged to the state university. Undeterred, she rode a train to St. Louis and rented silverware to serve seven hundred people. "I served that banquet and it brought me in $1,300."

Not everyone was a fan of the beaten biscuits. Sehon Williams remembers his teacher Bertha Sails had bridge parties in the summer, and she would send Sehon to Annie Fisher's to pick up the ordered biscuits. He was given one of the sought-after biscuits for his efforts. He didn't hold back when he said, "They were nasty—very sour!"

In the early 1920s, Annie Fisher built a large home in the country along Highway 63 that was known as the Wayside Inn. It was described as an elegant house and "a sumptuous place, with large cheery dining rooms and, one is told, well patronized by the many persons who like Annie Fisher's cooking." Prohibition was in effect in the 1920s, and Fisher told a reporter, "My house has been sprinkled by our minister and people can't get common around here. When they comes to Annie Fisher's they comes to eat, and if they want to do any high-ballin' they must do it before they come and after they leave."

Annie Fisher's accomplishments live on in written stories and articles, as well as stories passed down from generation to generation by those who remember her beaten biscuits.

THE ERASING OF THE SHARP END — URBAN RENEWAL

In 1958, the Columbia Land Clearance for Redevelopment Authority submitted an urban renewal plan that included the demolition of the Sharp End and surrounding black neighborhoods. Many black-owned homes were taken by eminent domain and replaced with public housing. The Sharp End businesses were eventually replaced with a multi-story parking garage on one side of Walnut Street and the post office on the other. A new business area was attempted one block west of the area and called the Strip, but it was not adequate to replace the once thriving culture of the Sharp End. Most businesses weren't able to relocate, including Vi's Café. Lawrence Lee, who owned the Elite Café at the time, opened a successful music venue on the outskirts of the city, called Breezy Hill. Ed Tibbs Sr. and Paul Britt opened Paradise Hill, also a music venue. Both places hosted touring musical acts including Ike and Tina Turner, B.B. King and Ray Charles.

The only physical reminders of the Sharp End that remain are the building owned by Ed Tibbs Jr. that is the home of Tony's Pizza Palace and the plaque on Walnut Street that summarizes the story of the historic area. The last sentence on the historical marker reads, "It was demolished during urban renewal, which suddenly and dramatically removed the nucleus of this self-contained black business community."

Gathering Places for Upscale Casual, Happy Hours and Special Occasions

From the late 1960s through the 1980s, the number of restaurants in Columbia grew dramatically, especially fast-food and chain restaurants. In the 1970 city directory, there were 73 restaurants listed, including 10 chain restaurants. When the 1981 directory was printed, the number had jumped to 115 restaurants, including at least 41 chain restaurants. New restaurants that provided an upscale but comfortable décor and menus with unique items appeared on the culinary scene, and diners embraced them. Restaurants like Bobby Buford's (which had an ad in a local restaurant guide that read, "Talk about atmosphere! Buford's is filled with many decorative and unique pieces from all over the world, featuring real carousel horses in the dining room") and the Katy Station (formerly a railroad train station, with dining tables inside actual refurbished train cars) quickly became go-to places for diners looking for restaurants to celebrate special occasions with upscale food options at reasonable prices. The Harvest Moon provided a "California Style" option for visiting college parents, those attending football games, businessmen and students on a big night out, as described by one of the owners, Dennis Harper. Restaurants like the Haden House and 63 Diner were on the outskirts of town and were considered destination restaurants, each with décor from a previous time, but in very different periods.

HADEN HOUSE

The Haden House was originally built in 1831 as the house and estate of Joel Haden and his wife, Sarah. After a fire destroyed it, the house was rebuilt in the early 1900s. Sarah Haden died from typhoid in the mid-1830s, and it is rumored that her ghost remained in the house. Different occupants of the house—both families who lived there and employees of the restaurants that operated out of the old house—reported unusual behavior. Employees of the restaurant reported dishes being broken, objects being moved and chairs sliding out from under tables without anyone doing anything.

In 1974, it became the nineteenth-century plantation-style restaurant that many locals and visitors flocked to and waited hours for a seat. It was a packed house in prom season, with high school students in formal attire taking pictures in the beautiful gardens and by the covered wagons along the driveway as they waited for their tables to be ready. This author personally has wonderful memories of prom dinner in 1986 with my now husband of over twenty-eight years!

The Haden House, also called Old Planation House at times, served "southern-style cuisine." Evelyn Harned wrote, "I loved their Cornish hen and cabbage casserole." Judy Armbruster reminisced about her visits there in the late '80s: "Loved singing at the piano with shrimp and potato skins! Wonderful food and atmosphere!" In a local newspaper article about Haden House, Columbia historian Warren Dalton was quoted as saying, "It was the most elegant place. It felt like you were privileged to eat there. For birthday parties, wedding parties and after football games, it was the place to go." He added, "Other local eateries offered good food and sophistication, but Haden House provided elegance from another century."

The excellent food at Haden House in the 1980s is credited to Chef Roi Smith. His only formal training was in the army's baking and cooking school during World War II. He worked in the service

Haden House (Old Plantation House) menu. *Collection of Melissa Applegate.*

for years and enjoyed a criticism-free time there, saying, "You didn't have to take any guff from the soldiers. If they didn't like your doughnut, you just stuck their nose in it." He became nationally and internationally recognized from various places he worked on the West Coast during the 1960s. Chef Roi first came to Columbia in 1967 to help Jack Crouch open the Original Jack's Coronado. In 1982, he was called out of retirement to help write the menu and organize the kitchen for the Haden House, which Jack Crouch had recently purchased. Chef Roi became part owner and executive chef of both Haden House and Bobby Buford's restaurants throughout the 1980s, providing the mouth-watering meals that those who enjoyed them still rave about decades later.

The ownership changed over time, and Haden House closed in 1995. Sadly, businesses that required several law enforcement visits took over the building. The once beautifully maintained estate and gardens became neglected and run-down, with little recognition of the once stately plantation house it had been.

THE 63 DINER

A huge plastic hamburger and French fries, the back end of a 1959 Cadillac protruding from the front of the building and a vintage gas pump greeted visitors upon arrival outside the 63 Diner. Once inside, there were many more nostalgic items to take you back to the 1950s, including life-size statues of Elvis Presley and Betty Boop. Lori Erickson shared, "When I was a kid, I always felt like I was entering into another era at 63 Diner. When there was a long wait, there was no shortage of cool things on the wall for a kid to investigate." The diner sat on land north of Columbia along Highway 63, hence the name. The 63 Diner was the culmination of a dream of owning their own restaurant that Norton and Mary Evans had when they were engaged and worked together at Bobby Buford's restaurant. Norton was a chef, and Mary was the general manager. They would talk about the food they liked and would serve at their future restaurant: burgers, chicken livers, ham and beans and malts. They even knew they would want to open on the north side of Columbia, where land was affordable and they could benefit from highway traffic.

Fast-forward to 1989. Norton and Mary were married, and their dream of owning their own restaurant came true upon opening the 63

Diner. They incorporated all their favorite foods on the menu. They had fun with the diner theme and carried it through the décor, the waitress uniforms and the menu. The most often-ordered items became the B52 sandwich and the malts. Guests also mention their love for the pies, so many pies: banana cream, peanut butter chocolate, coconut cream, chocolate banana cream and chocolate pie with M&Ms, to name a few! In addition to running the diner with Norton, Mary homeschooled her three children, Dakota, Josh and Cole, and would often bring all three to work. She remembers when she had a baby, three-year-old and five-year-old. The baby would be on the counter in a pumpkin seat entertained by a regular, the three-year-old would sit in a high chair with crackers and green beans and the five-year-old got to run the cash register (with a little supervision). Mary said, "I just made it work." Many customers would bring their families in on a regular basis. Shelly Herman shared her memories: "The 63 Diner was a great place to take the kids to step back into the '50s. The food and shakes were great. We had some fun family dinners there! Several dinners we had three generations there. Christmas decorations were fabulous inside and out. Loved when they decorated around the pond. It was magical." Former employees also remember it fondly. Karen Schultz said, "The 63 Diner…my sister Brenda managed the diner for many years. I managed at night for one year and worked there part time for 4 years when Mary and Norton opened it. What memories I have. One big Happy Family!" She also shared, "Working there was one of the best experiences in my life." A regular at the diner, Peter Laguna, wrote, "The best thing about 63 Diner was the people. Brenda, Mary, Norton…you walked in and the personal greeting made you feel at home. Mary and Brenda especially *were* the 63 Diner."

Norton and Mary's decision to offer "diner food" proved to be a savvy one. Elizabeth Harding lists roast beef, mashed potatoes, green beans and mushrooms as her favorites. "Bacon cheeseburger and onion rings. Handmade chocolate shakes!" were the favorites that Carol Vance shared. Another regular, April Cockrell, wrote, "The 63 Diner was a restaurant like no other. Mary and Norton Evans created a great little place just north of Columbia that people would wait in line (sometimes up to an hour) for a seat to enjoy delicious food at an affordable price. But the big draw was the decorations. It screamed 1950s throughout including the uniforms worn by the staff. They put Christmas trees on the ceiling, upside down during the holiday season. The landscape outside was immaculate. It is sadly missed."

63 Diner. *Collection of Norton and Mary Evans.*

Mary has a photo album of 63 Diner pictures, and you can tell how much fun she had and how much the staff and regular customers meant to her as she goes through the pages and talks about each picture. As she looks at pictures of guests at the diner for their special celebrations, she says, "There were tons of birthday parties there. I loved seeing little girls dressed up in poodle skirts with pink scarves tied in their hair." As Mary reflected on the old photos, she said, "You could rub elbows with everybody; it didn't matter what you did, everyone was equal."

In 2005, the Evanses made the decision to sell the diner to devote more time to family and their growing kids. The restaurant went through different owners, reopened in 2009 and closed in 2015 for the last time. Most people still associate their beloved memories of 63 Diner with Norton and Mary Evans. Steven Alexander summed up his feelings and wrote about the diner being demolished:

> *From the time they opened in 1989 until around 2005, I was a regular there. There was always a line out the south door. It was a vibrant place with a lake to the south and a park-like wooded area behind where fun car shows were held. The food was great and reasonably priced. Sad times for*

the property for the last several years. It will meet its demise permanently as what is left will be auctioned piece by piece including the doors later this month. It was a re-creation of AMERICANA that was disappearing and the Re-creation is also going away.

When asked if she had any regrets about the 63 Diner, Mary Evans shook her head and said, "No regrets. I left totally in love with it."

B52 Sandwich

Use a 6-ounce sirloin steak, preferably cubed, and then dredge in cracked black peppercorns on one side and then grill. Once grilled, top steak with chopped green onions, crumbled well-cooked bacon and, last of all, top with Béarnaise Sauce. Serve on a grilled Kaiser bun. Substitute a chicken breast for the steak and it becomes another 63 Diner menu favorite, the Road Runner.

Chocolate Banana Cream Pie

10-inch cooked pastry shell
1 bottle prepared fudge topping
1 large banana, sliced
1 large box instant vanilla pudding/pie mix (prepared according to package directions for making a pie)
Fresh sweetened whipped cream
Mini chocolate chips or shaved chocolate for topping

Spread bottom of cooked pastry shell with one-quarter-inch layer of fudge sauce, then cover with banana slices. Next, cover with the prepared pie filling, then the whipped cream and sprinkle with either mini chocolate chips or chocolate shavings. Chill in refrigerator for at least 3 hours before serving.

FLAMING PIT

A mall isn't where one would normally expect to find a "nice" steak restaurant, but in 1966, the Flaming Pit came to Columbia and occupied the southeast corner of the Parkade Plaza Shopping Center. The Flaming Pit was one of several in a privately owned chain based out of St. Louis. An ad in the June 14, 1964 *St. Louis Post-Dispatch* explains why the chain was growing and lists the standards for what diners could expect at Flaming Pit. It reads:

> *In just five years "Flaming Pit" has grown to be one of the leading restaurant names in the St. Louis area. There are many reasons for this: the charming informal décor that folks enjoy; the special way we have of catering to the youngsters that families appreciate; the reasonable prices; our excellent service and pleasant table appointments; our convenient locations and large, well-lighted parking lots; but most of all it's the food!…Every salad is crisp and tasty, Every baked potato is snowy white and piping hot, Every French fry is crisp and toasty brown, Every steak is tender with the delicious flavor and aroma of open-hearth charcoal broiling, Every cup of coffee is piping hot and delicious, The quality of our food never varies—it's always the tastiest.*

These qualities carried through to the Columbia location, and it quickly became a local favorite and was often referred to as "The Pit." It had a very comfortable dining room with a large open fireplace (firepit) and one of the first, if not *the* first, salad bars in town. Many locals immediately think of the huge chunk of cheese as the main feature of the salad bar when reminiscing about the Flaming Pit. Vincent Keene shared, "Loved the big cheese wheel that you know every kid in there put their hands all over. Ate the cheese anyway.…Treasure box was cool but the cheddar cheese wheel had you going back for more. Loved the dark setting."

The treasure chest was a fun treat for young diners. Everyone twelve years and under got to select one of the wonderful "treasures" as a souvenir from their evening. Treasures such as bouncing balls, small figurines or yo-yos were great fun and could keep a young child entertained for hours. Remember, this was a time before handheld video games, iPads and cellphones. Dave Woodman remembers visiting the Flaming Pit when he was young: "It was dark, with comfortable booths and a fire pit in the dining area. The treasure chest assured that it was a hit with the kids; the smell of charbroiled meat was

a hit with the adults. For us kids, it was, at the time, the fanciest restaurant we were treated to."

In addition to the dining area, the bar became a favorite happy hour place for locals to partake in "Double Bubbles" (two-for-one drink specials). Mark Kitch worked at a retail store in the Parkade Plaza Shopping Center and would visit the Flaming Pit lounge a couple of times a week. He summarized his memories of the Pit as, "Great happy hour! Big Brandy sniffer [*sic*] glasses and BIG block of cheese!" It also became a go-to place for teachers for Friday happy hours celebrating the end of the week with Double Bubbles.

The Flaming Pit was known as the place to go for a great steak in Columbia. The meat was purchased from a meat company in nearby Jefferson City, and then the steaks were cut at the Flaming Pit. The "steer burger," a ten-ounce burger, was also a popular item for meat lovers with a large appetite. Many also remember the Pit for the frog legs, which were available on a regular basis.

The banquet rooms were very popular and hosted many events, including wedding receptions, trade association meetings, high school senior banquets, anniversary celebrations and even the Mizzou football team banquets. Those who frequented the Flaming Pit remember some then unknown (now well-known) celebrities working there as MU college students. Brad Pitt was a busboy, and Sheryl Crow performed covers in the lounge with the band Cashmere. Laura Willis Getty remembers another well-known diner at the Flaming Pit. Laura was not a diner but was on duty with the Columbia Police Department. She remembers, "My first protection detail was at the Flaming Pit for Mrs. Walter Mondale, who was solo on the campaign trail for her husband."

The Flaming Pit was enjoyed by many who still have wonderful memories of the big cheese wheel, the treasure chest and Double Bubbles, but sadly, it closed in the mid-1980s. This was the same time the new "modern mall," the Columbia Mall, was built, and the Parkade Plaza anchor store, JCPenney, moved there. A junior college now occupies the corner that once was the destination of locals looking for a great steak dinner.

INTERSTATE PANCAKE HOWSE

Pancakes may be what were expected when diners first visited the Interstate Pancake Howse, but what they found was a full breakfast, lunch and dinner menu. In 1966, after experiencing success with their drive-ins, brothers

Ken (Poor Ken) and Del (Lonesome Del) Gebhardt decided to feature their secret family pancake recipe at a twenty-four-hour sit-down restaurant just off Interstate 70. An investor from California talked them into building the restaurant. However, they quickly found out that the investor had no money but brought in four people from California to train employees and run the operations of the restaurant. This was in the spring, and when the first snow came in late fall, the Californians decided it was too cold and "up and left" back to their warm home state.

The brothers struggled to keep going without the staff that had been operating the restaurant. However, they were not ones to give up, and Ken wanted to come up with a commercial that would be entertaining and memorable to attract more customers to the restaurant. They decided on a classroom setting where one of the brothers would be the teacher and the other would be the student. Poor Ken was the teacher at the chalkboard trying to teach Lonesome Del that "Pi R squared." Lonesome Del would respond, "No, pie are round!" This was repeated a few times with the volume and irritation from both sides increasing every time. Finally, Lonesome Del couldn't take it anymore and threw a pie in Poor Ken's face. The commercial ended with Poor Ken saying, "Pie are messy." It was aired on a local TV station and was an immediate hit. Classes from area schools visited Interstate Pancake Howse for field trips, customers would say, "Pie are messy" when they came to eat and Ken was invited to judge many pie contests. He remembered one in nearby Fayette, Missouri, for the county fair. He was sampling pies and recording his thoughts on the scorecard, and then someone threw a pie. All of a sudden, everyone started throwing pies, and Ken had to go through a carwash to clean off before he could go home! He also remembers a group of Stephens College sorority girls coming to the restaurant, and one girl in the group threw a pie in Ken's face. Ken just stood there surprised for a moment, and the girl started crying because she had thrown the pie as part of a dare and then immediately felt bad for doing it. Ken finally just started laughing, and once the girl realized that she had caused no harm to Ken, she started laughing too—but she still kept apologizing! Even today, people still refer to that commercial when Interstate Pancake Howse comes up. Richard Van Hoosen commented, "Pie are squared. Pie are round. Pie are messy. It's been over 30 years and I still remember those commercials."

The commercial was so successful that the Gebhardt brothers wanted to keep it going. However, when it came time for renewal, the local TV station refused to air the commercial. The sales manager said, "We saw fit not to accept their commercials." Ken and Del were told by the station

that the commercial was not up to their standards. The brothers wanted to keep the momentum going that the commercial had created, so when their attorney said, "Let's sue them," they went for it. Their attorney filed a letter of complaint with the FCC, and the "injustice to the brothers" became the talk of the town. Ken remembers it being a hot topic on a local call-in talk radio show for over a year. The commercial was never re-aired, but Ken remembers the publicity gained from the lawsuit was "the best thing that ever happened for business."

The pancakes weren't just the usual pancakes that one might expect, but then, Poor Ken and Lonesome Del weren't just usual guys. They started with two different pancake batters: buttermilk for the basic pancakes and French for the filled pancakes. The buttermilk batter ended up being more preferred by customers. The recipe for the buttermilk pancake batter is said to have been passed down for generations in the Gebhardt family, and the story was featured on the back of one of the restaurant's first menus. The Gebhardts are from Glasgow, Missouri, which was once a popular port of call on the Missouri River, with its population being mostly of German origin. The legend is that Great-Grandma Gebhardt was famous for her German Chocolate Cake, made from her secret recipe that she refused to share. A chef on a fine paddleboat named *Queen Bella Maria* tasted Grandma Gebhardt's cake and unsuccessfully pleaded for the recipe. Finally, a trade was agreed upon, and the chef left with the coveted German Chocolate Cake recipe, while Grandma Gebhardt received his prized recipe for pancakes and syrup. The chef drowned two days later when the paddleboat burned and sunk. The pancake recipe was carefully guarded and passed down through the Gebhardt family and was later served to customers at the Interstate Pancake Howse. So the story goes...or perhaps Ken's wife, Martha, came up with the recipe after lots of trial and error. The legend of the *Queen Bella Maria* makes for a more interesting story, so we'll go with that!

One look at the Interstate Pancake Howse menu and it's immediately apparent that the Gebhardt brothers liked to have fun. Their sense of humor was on display with not only the names of Poor Ken and Lonesome Del but also Maître Syd and Maître Diz, along with the general manager, More Fun. The menu was full of entertainment. In small print under the section title of "Waffles" was the phrase "we are semi-famous for our waffles." In small print after "Pie" was "in the face." The "Lo-Cal Plate" stated it was less than 1,974 calories. After the section title "Char-Broiled Steaks" read in small print "all steaks cut from beef butt one" (that would be the ham steak). A later menu spelled egg as *aig*. The menu even included a tip of the hat to

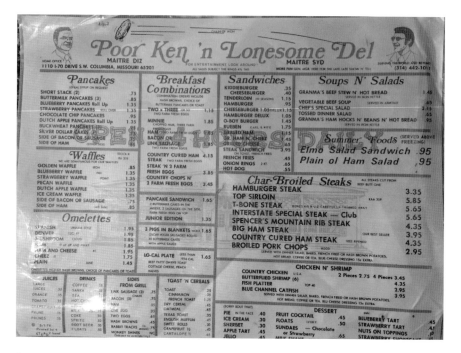

Interstate Pancake Howse menu. *Collection of the Gebhardt family.*

the O-Boy Drive-In's O-Boy Burger. After the Fish Sandwich read in small print "didn't get away."

A cup of coffee was four cents, which might explain, in part, why it was a popular hangout after the bars closed. Ron Coleman, one of the general managers, remembers, "Once the bars closed, everyone would come there [Interstate Pancake Howse] totally trashed." The restaurant didn't serve alcohol, but several who showed up already had plenty in their systems before arriving. Ron remembers some after-bars customers passing out, and he would have to drag them to the office at 5:00 a.m. on Sunday so that the church crowd wouldn't see them. He also remembers Poor Ken and Lonesome Del asking him to change his name to Ronald McPancake, but he just couldn't go that far.

Ken and Del liked to be where the action was and maintained their office in a booth in the dining area, complete with a phone and all other needed office supplies. They had fun, but they were also forward-thinking entrepreneurs. In the late 1970s, they were written about in *National Restaurant Association Magazine* for being the first restaurant in the nation to go completely computerized. Ken also remembers purchasing

a monogramming machine for matchbooks. This was a time before the smoking ban. Ken would visit with diners who were smoking, find out their names, disappear for a little while and then reappear to present the diner with a personally monogrammed matchbook.

Ken and Martha moved to Texas for several years and ran a very successful European antique furniture auction business. The Interstate Pancake Howse building was flattened, and Lonesome Del passed away. Ken and Martha have now retired and moved back to their hometown of Glasgow, Missouri. When asked what made Interstate Pancake a place that people kept going back to, Ken answered, "The atmosphere of friendliness, excellent food, clean and fast service." It's no doubt that the personalities of Poor Ken and Lonesome Del kept people coming back too!

BOONE TAVERN

In homage to the historic Daniel Boone Tavern that once operated on Broadway, Dick Walls decided to open a new upscale restaurant in 1978 that could become a gathering place for Columbia's locals and named it Boone Tavern. Walls already had decades of restaurant experience as a manager of the Italian Village and owner of both the Heidelberg and Hofbrau restaurants. Dick hired a general manager who had previously been at Bobby Buford's restaurant and brought the chefs from there with him. They used their expertise and came up with menu items that were related to the old Daniel Boone Tavern, added some items that were current trends and came up with a menu that included appealing choices at affordable prices.

In addition to a large dining space, bar area and lower-level banquet rooms, the restaurant boasted one of the first and largest outdoor dining spaces, which it called the courtyard. It rapidly became the place to be and be seen, especially on Friday nights beginning with happy hour. It was located next to the county courthouse on Walnut Street and close to many downtown law offices, so it became a natural hangout for attorneys. It was very popular for large gatherings and was reserved for many fraternity and sorority mom-and-dad weekends, graduation parties and business after hour get-togethers. One parents' weekend that the staff laughs about now, but not at the time, was when they were using all staffing resources to accommodate the large crowd of customers and a fire broke out in the basement of the

restaurant. All of the forest-green linen napkins were washed and dried in the basement, and one of the big dryers had caught on fire.

Prime rib was one of the most popular items on the menu, but the buffalo chicken wings, broccoli cheese soup and butcher-block croissant were favorites as well. Burger Madness became a big draw for happy hour crowds, with half-priced burgers and discounted beer pitchers. Boone Tavern was also known for the Sunday brunch, where made-to-order omelets, smoked salmon, fried chicken and fresh-made raspberry cream pie were just some of the offerings. The Sunday brunch was outside of most college students' budgets, but if their visiting parents wanted to treat them to brunch, Boone Tavern is where they would go.

Dick Walls enjoyed his role as the owner and has great memories of hosting nationally known celebrities such as basketball coach Bobby Knight and feminist Gloria Steinem when she was visiting Stephens College. When he speaks of the local "celebrities" he hosted, you can tell from the smile on his face that he has great memories associated with those gatherings as well. Opening night of the Stephens College theater productions would end with the cast and crew celebrating at Boone Tavern. When the Katy Station restaurant closed, the Round Table men's group—and its round table—made Boone Tavern its new meeting place, meeting every weekday for lunch at a reserved space at the front window.

Dick Walls credits his success to a very good staff, and specifically names Jim (Hoss) and Trish Koetting. The Koettings had a long tenure with Boone Tavern in several different roles, and many locals also associate them with Boone Tavern's success and popularity. Hoss worked there for eighteen years as a cook, kitchen manager and then general manager. Trish started a couple of years later and, during her sixteen years with the company, filled many different roles, including cocktail waitress and management roles at Boone Tavern and other restaurants owned by Dick Walls. She later became director of operations for the Walls restaurant group and was responsible for booking all banquets and catering, as well as advertising for all the restaurants and all training at Boone Tavern. Clearly the Koettings were very valuable in the running of Boone Tavern.

Trish credits Dick Walls's innovative promotions with helping to fill up the restaurant. One of these was the Boone Tavern VIP card. This was before the days of widespread credit card use and every business having its own credit card, but it worked essentially the same. Customers could apply for a card and, if accepted, could charge their food and drinks and then get billed at the end of the month. It was a great success, and

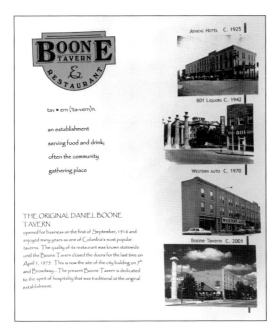

tav • ern ('ta-vern)n.

an establishment

serving food and drink;

often the community

gathering place

THE ORIGINAL DANIEL BOONE TAVERN
opened for business on the first of September, 1916 and enjoyed many years as one of Columbia's most popular taverns. The quality of its restaurant was known statewide until the Boone Tavern closed the doors for the last time on April 1, 1975. This is now the site of the city building on 7th and Broadway. The present Boone Tavern is dedicated to the spirit of hospitality that was traditional at the original establishment.

ATHENS HOTEL C. 1925

801 LIQUORS C. 1942

WESTERN AUTO C. 1970

Boone Tavern C. 2001

Boone Tavern menu front.
Collection of Dick Walls.

all the regulars wanted to be "VIP" members. Whenever new coaches arrived at the University of Missouri, Dick Walls would promptly send them Boone Tavern VIP cards, knowing that many Mizzou fans wanted to hang out at the same place as the coaches. He also had designated VIP rooms in the dining area, something that no other Columbia restaurant had at the time.

Trish enjoyed her time at Boone Tavern, especially "those happy hours and weekends when the courtyard was hopping busy." When asked what her favorite thing about her time with Boone Tavern was, she responded, "Meeting the enormous amount of people that came in. Many are still friends and acquaintances with us today." Hoss and Trish were married during their time at Boone Tavern, and once their first son came along, they made the decision to leave and start their own restaurant where they could better control their hours. Many of the former Boone Tavern regulars are now regulars at Hoss's Market and Rotisserie, the Koettings' restaurant and market located on the south side of Columbia. Trish still thinks highly of her time at Boone Tavern and is proud of the mark it made in Columbia's restaurant history. She says, "It was a classic, locally owned restaurant that had good food at affordable prices and you could meet your friends in a relaxed atmosphere. It was Columbia's social scene in the lounge and courtyard. It truly was Columbia's gathering place."

Dick Walls sold the restaurant in 2012. He still cherishes the memories he has of the staff and regular customers at Boone Tavern and sums up why so many people remember Boone Tavern as their favorite restaurant of the past, as "the atmosphere, menu and the courtyard was a huge draw." Bleu restaurant took over the space but closed in 2016. A new office building has taken the place of the beloved courtyard, and the restaurant space still sits vacant, leaving locals wondering what new gathering place will find a home within those walls.

JACK'S GOURMET

The restaurant that was last known as Jack's Gourmet has a long history with fine dining and celebrating special occasions in Columbia. The first restaurant located at the same address, along what is now called Business Loop 70 East, was the Coronado Club, open from 1927 to 1951 under the ownership of Max Sigoloff. A 1935 ad reads, "Visit the Coronado, fun and gaiety at Columbia's Smartest Inn." The February 1945 edition of the *Black Stocking*, a University of Missouri student publication, described the Coronado: "There are above average steak dinners and plenty of bottled beer, but everybody takes a fifth and orders mixer. In warm weather things are more interesting at a lawn table....Be sure to call for reservations on weekends, for that's when the crowd moves in. There's no cover, good table service, and an interesting crowd." It changed owners and was known by different names, including Red & Mel's, Jack's Coronado and finally Jack's Gourmet. Red & Mel's was known more as a roadhouse than a destination for fine dining, with a reputation of a risqué atmosphere. It changed ownership a couple more times before Ken Applegate purchased the restaurant in 1972 with co-owners Helga and Baldur Werner; he bought them out in 1979.

Ken Applegate had an extensive restaurant background before becoming the sole proprietor of Jack's. He worked in several top restaurants in the Kansas City area before moving to Columbia to manage the University of Missouri Student Union cafeteria. In the 1970s, when Ken purchased Jack's Gourmet, it featured a large bar and disco and was considered more of a place to go drink and dance than to get a good meal. Ken had a passion for food and wanted to use his experience in the restaurant industry to provide a place that offered menu items that no other restaurant in Columbia had at the time, such as veal and escargot. Everything was made from scratch.

Jack's Gourmet. *Collection of Melissa Applegate.*

Longtime local Ed Blakey wrote, "Our family has had so many wonderful times at Jack's over the years. We had the pleasure to be there on the very last night it was open." When asked what his favorite thing to order was, he replied, "Love me the escargot and we loved our favorite server Jimmy. He would always take care of us." Iona Rippeto Jones was also a fan of the escargot and said, "First time I ever ate Escargot. Loved it." She went on to say, "In fact, because I enjoyed Jack's, I compared every other Escargot to it. Even when I ate in Paris."

The building itself was an ordinary brick building with a strip mall, radio station and hardware store as neighbors. However, upon entering the building, you were met with glamour everywhere your eyes fell. Ken's wife, Melissa, began working at Jack's Gourmet in 1997. She describes the décor as "Mafia Chic." The dominant color was red—red oversized booths and red shag carpet set against freshly pressed white linen tablecloths. A large ornate chandelier hung prominently in the middle of the dining room. A fire in 2001 required a renovation. Some changes were made, but the style of "Mafia Chic" was still present. Judy Snyder remembered the atmosphere and wrote, "Jack's Gourmet restaurant made me feel so fancy and special! I loved the food, but I was so impressed with the red plush velvet chairs and booths and the service and the atmosphere. I have never been to another place with the same feel."

The dining room also had a very romantic feel and became the setting for many proposals, anniversary celebrations and Valentine's dinners. Ken and Melissa Applegate even celebrated their own wedding there. Ken felt the circular booths along the walls were perfect for a romantic evening spent over a meal because they allowed two people to sit together instead of across from each other with a table separating them. When talking about all the engagements that took place at Jack's, Ken said, "This is the most romantic place on earth."

In addition to serving customers at the restaurant, Jack's was highly sought after for catering. Alan Dodds, a former catering employee, is the owner of Tropical Liquors in Columbia and said that he learned a lot from his time working at Jack's, including, "There was always a way to make it work and pull off the event." Jeff Porter was a waiter and on the catering staff during the 1990s and remembers Jack's as the last of the old-school restaurants. The waiters were professionally trained, and their dedication to service was a career, not a job to get through college. Jeff remembers Ken as an owner who could always be found in the kitchen doing whatever needed to be done, whether it was washing dishes, cooking or helping with salad prep. He also never missed an opportunity to go to the dining area and visit with diners.

Owners Ken and Melissa Applegate's 1996 wedding reception at Jack's Gourmet. *Collection of Melissa Applegate.*

A favorite memory of Jeff's involves the "Gator," which was the name given to the station wagon with only a front seat, with the back cleared for delivering to catered events. On the way to a catered barbecue, Ken Applegate was driving, with Jeff and another coworker riding snugly in the front seat, with a carload of hot dishes, when a car pulled out in front of Ken. He slammed on the brakes, and gallons of baked beans proceeded to fill the floorboard of the Gator. Ken put a call in to his sister Carol back at the restaurant on the very large cellphone and said, "We've spilled the beans!" She asked, "How many do you need?" He said, "One million beans!" threw down the phone and proceeded to drive in ankle-deep baked beans with fogged-up windows from the heat of the beans that had filled the car.

Jack's became a go-to for many visiting celebrities, including Stevie Wonder, Kate Capshaw, Brendan Fraser, General George Casey, Mr. T and Joe Namath. Namath was such a fan that it is rumored he considered buying Jack's. There was no formal inquiry to the owners, but there was enough circumstantial evidence among conversations he had with locals in the area to substantiate his interest. It certainly makes for a fun story! Many of Jack's meals were catered to planes with passengers heading to Mizzou football bowl games, and meals were even delivered to planes for the Press Corp when Presidents Clinton and Bush visited Columbia.

Jack's was known for fine dining and upscale tableside presentations. When the cart pulled up next to a table, guests knew something delicious involving a flame was about to be prepared. Steak Diane Flambé, Chateaubriand, Baked Alaska, Bananas Foster Flambé and Cherries Jubilee for Two provided entertainment as much as they provided a delicious dish to savor. The Bananas Foster was even voted Columbia's favorite dessert.

Ken received awards from the restaurant industry for his success on a professional level, but it is the sentiments of former employees and diners that demonstrate the impact Ken Applegate and Jack's Gourmet had on Columbia. Angie Sullivan Parker's father sold produce to Jack's Gourmet and was good friends with Ken. She shared one of her memories from younger days: "Clifton was one of the cooks, way back when. When Jim Pitts (the greatest waiter on the planet) took my order there one night, I said I wanted peanut butter and jelly, so Clifton sent someone to the store and they came back with Goober & white bread and I had my pb&j with no crusts and a HUGE bowl of maraschino cherries for my 'salad.' I was probably 8 years old." She continued, "These people were my family, for a long time. I told my parents I was getting married there, I had my reception there, told my parents we were having a baby there and had a baby shower

there! I can't believe it's not going to be there now." After over forty years of dedication to his dream of owning Jack's Gourmet, Ken Applegate passed away in 2016.

For a short time after Ken's death, Jack's remained open, and then Melissa made the decision to close the restaurant. She saved some of the iconic items from Jack's, including the famous awning over the door and the martini menu that Stevie Wonder autographed. The items she didn't keep were auctioned and the building was bulldozed, but the memories remain. For those wanting a taste of nostalgia, Melissa shared the recipe for a favorite from Jack's. Enjoy!

Jack's Gourmet French Onion Soup

¾ cup butter
4–5 cups jumbo white onions, sliced
5 cups beef broth or consommé
2 whole bay leaves
¼ cup cooking dry sherry
1 tablespoon Kitchen Bouquet
salt and pepper, to taste
French baguette (4 slices for each soup)
¼ cup shredded parmesan as topping

Melt butter in stock pot and add onions. Cook until tender and translucent. Add broth, bay leaves, sherry and Kitchen Bouquet. Simmer for 30 minutes. Season with salt and pepper as needed. Ladle soup into 4 oven-safe bowls, top with sliced baguette and add shredded parmesan cheese on top. Put bowls on cookie sheet and broil in preheated oven until brown. You can substitute sliced Swiss or provolone as well.

Satisfying Columbia's Sweet Tooth—for All Ages!

Local bakeries, candy shops and ice cream parlors have been satisfying Columbia's sweet tooth as far back as the 1800s. A sales receipt dated July 27, 1897, for Gerling's Bakery and Confectionery lists the offerings on the top of the receipt: "Breads, Cakes and Pies, Fine Candies, Cigars, Fruits, Nuts, Etc….Always on Hand. Ice Cream and Fresh Oysters in Season." A very interesting combination! An ad for Gentsche's Bakery that reads, "For Fresh Bread, Fine Candies, and meals at all hours" dates back to 1906. A 1910 *Farmers Fair Official Guide* includes advertisements for Harris Candies at 16 South Ninth Street and Dawson & Hale Bakery and Restaurant at 14 North Eighth Street. A 1935 city directory lists three bakeries in the downtown area: Columbia Baking, "Home of Pan Dandy Bread"; Model Bakery; and Strengs Sally Ann Bread Shop. More recent sweet shops became favorites in the community as Columbia grew.

CENTRAL DAIRY PEPPERMINT ROOM

In 1920, Dot Sappington and Clyde Shepard founded Central Dairy Company. Clyde Shepard had a dairy farm in eastern Columbia, where Shepard Elementary School stands today. Originally, the dairy was on Eighth Street and moved to 1104 East Broadway in 1927. When the dairy started in Columbia, it was a production facility, and the local milkmen

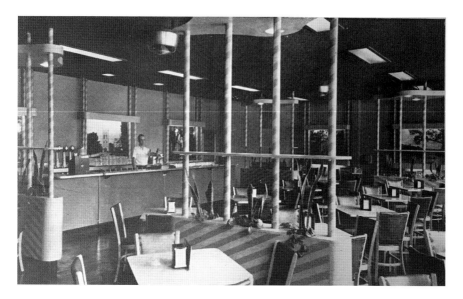

Central Dairy Peppermint Room. *State Historical Society of Missouri.*

would line up along Broadway to fill their trucks for their daily deliveries of milk in glass bottles to insulated metal boxes on front porches all over Columbia. Dot later sold his share to his eldest son, Roy, and started a new Central Dairy in the capital city of Jefferson City, about thirty minutes south of Columbia. In the 1940s, an ice cream parlor, the Peppermint Room, was added to the Broadway building. It became a local hangout for high school students during the 1940s and '50s, as well as a place for locals to enjoy an ice cream cone.

Roy's son Bill Sappington remembers spending many hours of his youth at Central Dairy. His father wanted to start selling strawberry ice cream and contracted with Alexander Truck Farm to purchase strawberries but needed cheap labor to take the stems off the fresh strawberries. Bill and four of his Grant Elementary classmates were paid one cent per box (there were twenty-four boxes to a crate) to prepare the strawberries. Bill remembers they each would put a large bucket between their legs for the strawberries, and the stems went back in the box. Once the bucket was full, they would take it into the dairy and put it in the cooler. The rotten strawberries got put aside so they could throw them at each other when their task was completed—a fringe benefit of the job for school-age boys!

Bill also remembers sneaking over to the bowling alley next door, slumping down in a seat to hide and watching the Stephens College "girls" bowl. It

wouldn't be long before he would hear knocking on the window behind him and see his dad letting him know it was time to get back to work.

Eventually, all the Central Dairy operations were moved to Jefferson City. The Columbia building is now in the National Register of Historic Places, and Downtown Appliance is located there.

BUCK'S ICE CREAM

Tucked behind a dormitory on the University of Missouri campus is a hidden gem of an ice cream shop with a unique beginning and business plan. MU Food Science students operate Buck's Ice Cream out of Eckles Hall and are responsible for production, marketing and sales. Ice cream research began at Mizzou in the 1920s by Professor William Henry Eddie Reid and his graduate student Wendell Arbuckle. As part of the dairy science department, there was a small retail store that from 1920 to 1972 sold basic vanilla, chocolate and strawberry ice cream for five cents a scoop. It also sold various milks, butter and cheeses, as well as supplied MU cafeterias with dairy products. In 1972, production and sales were shut down due to lack of funds for needed upgrades to production equipment that had been part of the original dairy lab built in 1904.

Meanwhile, Dr. Wendell Arbuckle had made a name for himself in the ice cream industry, including as a consultant for Baskin Robbins. He literally "wrote the book" about ice cream as the author of the first through third editions of the textbook *Ice Cream*. When he retired, he wanted to give back to the University of Missouri and created an endowment in 1986 to support ice cream research on campus. Experts in the ice cream industry were invited to be consultants on remodeling Eckles Hall and the lab to update the ice cream making facility. This included Dr. Robert Marshall, a microbiologist professor in the dairy program, who led pioneering research in the creation of low-fat ice cream. He was the author of the fourth and fifth editions of the textbook *Ice Cream*.

Donations were secured from the private sector, including a batch freezer from Anheuser-Busch of St. Louis. Private donations combined with Dr. Arbuckle's endowment allowed for a state-of-the-art dairy lab and a new ice cream parlor, Buck's Ice Cream. It was named after Dr. Arbuckle, opened in 1989 and is open to the public. However, locals know that the best time to visit is when the university isn't in session so parking is easier. Dr. Marshall

wanted to create an ice cream flavor unique to Buck's and, after much trial and error, achieved success. In 1989, Tiger Stripe ice cream—French vanilla ice cream with dark Dutch chocolate stripes—debuted at Buck's Ice Cream shop. It has been the signature ice cream flavor of the University of Missouri ever since. Not only is it sold at Buck's Ice Cream, but Dr. Marshall is very proud that local grocery stores and a restaurant also sell it. It is also served at many MU events, including the annual Mizzou Freshman Walk, where all freshmen get introduced to Buck's with a sample size of Tiger Stripe ice cream. Buck's offers year-round flavors, including Tiger Stripe and Mizzou Gold, as well as seasonal flavors that cycle throughout the year.

THE CANDY FACTORY

The smell of rich chocolate in the air, the sight of every shelf and surface filled with a different confection and the sound of footsteps on a well-worn wooden plank floor transport you to an old-fashioned candy store as you walk in the door of the historic building that sits on the corner of Seventh and Cherry Streets. For over forty years, the Candy Factory has been delighting Columbia's taste buds. Georgia Lundgren began by making candy out of her home for family and friends who liked it so much they encouraged her to open a store and sell it, so that's just what she did. In November 1974, Georgia opened the Candy Factory in a small shop located at 906 East Walnut and began selling her handmade chocolate candies.

Georgia was the mother of young children at the time and incorporated her family into the business. Her husband was her bookkeeper, and her children, Chris and Diane, had the enviable position of taste-testing for quality control. After steadily growing the business and relocating around the corner to 117 North Ninth Street and then 1018 East Broadway, Georgia sold the business. On July 1, 1986, Sam and Donna Atkinson purchased the Candy Factory, along with Georgia's treasured recipes. Columbia residents had developed quite a taste for the Candy Factory treats, and hand-dipping candies could no longer keep up with the pace of demand. The Atkinsons invested in an enrobing machine to help automate the dipping process, while still maintaining the quality of the product.

The Atkinsons continued to grow the business and moved west on Broadway to the historic Hetzler Building in 1989 and then to their current location, 701 Cherry Street, in 1999. The current location began as a stable

The Candy Factory in the Hetzler Building. *Collection of the Atkinson family.*

and livery. The local newspaper, the *Columbia Daily Tribune*, built the current brick building and occupied it until it outgrew it. Many college alumni remember it later as the comedy club and bar Déjà Vu. The Atkinsons completely transformed the space from a bar to a true candy shop and factory reminiscent of a scene right out of the movie *Willy Wonka and the Chocolate Factory*. On the ground floor is the store that sells not only every type of candy imaginable but also several unique gift items. Take a trip through the pink door and up the stairs with the red-and-white peppermint-striped handrail, and you will find yourself in a brightly painted room with oversized lollipops, chocolates and hard candies covering the walls and several large windows that invite visitors to look into the "candy factory." The increasing demand has allowed the Atkinson family to add more enrobing machines, and the process of the conveyor belts carrying handmade Oreos, creams, caramels and even potato chips through the waterfalls of milk, dark and white chocolate is quite a sight to see. It has become a very popular field trip destination for Columbia elementary schools.

Sam and Donna's son Mike and his wife, Amy, joined the family business in 2005 to become the next generation of Columbia's hometown candy makers. On July 1, 2016—thirty years to the date that Sam and Donna purchased

the Candy Factory—ownership and the legacy of making Columbia's favorite candies were turned over to Mike and Amy Atkinson.

Katy's (pecans, almonds or cashews drenched in the secret recipe caramel and topped with chocolate), decadent truffles and almond toast (similar to an English toffee) are some of the more traditional popular items at the Candy Factory. Chocolate-covered potato chips are quickly becoming a favorite as well. However, the store is best known for its enormous chocolate-covered strawberries. Every year, the Candy Factory scours the country to find the ripest, juiciest fresh-picked strawberries available. The berries are then drenched in the Candy Factory's

The Candy Factory owners, Mike and Amy Atkinson. *Collection of the Atkinson family.*

rich milk, dark or white chocolate. On Valentine's Day, it is a familiar sight to see customers from all over mid-Missouri flock to the Candy Factory to buy these special chocolate-covered strawberries, which have become a tradition for many.

Mike Atkinson is very enthusiastic about his family's contribution to Columbia history and shared why: "I enjoy interacting with customers, the freedom to explore new candies and giving back to the community." In addition to the chocolate candies made from the recipes of original owner Georgia Lundgren, Mike likes to experiment to come up with new combinations, like the recently added butterscotch cheesecake ganache–filled chocolate. Mike and Amy enjoy continuing the tradition of the hometown candy shop that keeps generations of locals and visitors coming to the Candy Factory to satisfy their sweet tooth.

TROPICAL LIQUEURS

The over-twenty-one crowd in Columbia has been going to Tropical Liqueurs for over thirty years for a sweet treat in the form of an adult slushy. In 1985, current owner Alan Dodds's parents, Mary Dodds McCarthy and

Ira Dodds, introduced Columbia to a new kind of bar. They had family in Louisiana, where daiquiri bars were very popular, and they correctly predicted that they would be a hit in the college town of Columbia. After a trial-and-error process of coming up with different flavors, the first "Trops" opened downtown on Seventh Street and then moved to its current location on Broadway in 1991. Of course, since Columbia is the "Home of the Tigers," a flavor had to represent the Black and Gold. The Tiger Paw—a mixture of rum, peach schnapps, pineapple juice and orange juice—was the answer and has become the most popular frozen concoction on the menu. Other favorites include Cherry Bomb (vodka, cherry mix and lemon sour), Sweet Tart (vodka, triple sec, cranberry juice, grenadine and lemonade) and Toasted Almond (coffee liqueur and amaretto blended with vanilla ice cream). The popularity of Tropical Liqueurs allowed for a second location in south Columbia in 2001, as well as locations in Springfield, St. Louis and Kansas City.

The white Styrofoam cup with a red straw is a hallmark of Trops, as are the brightly colored walls with a tropical flair and the large painting with a tropical scene on the side of the downtown location. The painting doesn't include the name "Tropical Liqueurs" or any words. When the downtown location opened, there was a restriction on the size of signs on a building but

Tropical Liqueurs downtown. *Collection of the Dodds family.*

no restrictions on artwork. Ira Dodds had a degree in art, so he put his talent to work to come up with a creative alternative to a sign and made a large colorful painting to hang on the outside of the building. The tropical scene has become a part of Tropical Liqueurs' identity.

The university and college homecoming and graduation weekends make for especially long lines at Tropical Liqueurs, as students and visiting alumni are consistently a large part of the business. College students aren't the only fans of the frozen drinks. Locals line up out the door in the summer months as well. Alan Dodds attributes the success and longevity of Tropical Liqueurs to the unique product and it being different than a normal bar because of the atmosphere. "It's not dark, and the patio areas are conducive to conversations." Alan continues, "We've been in operation for over thirty-two years. People associate Trops with their time in Columbia. A lot of people say, when they come back for football games, Trops is the first stop. It's associated with fun memories of their time in college."

They're Still Going

Columbia's Oldest Restaurants Serving Up Big-City Offerings with Midwest Hospitality

Columbia has many beloved restaurants that, for different reasons, are no longer in operation. However, it is also fortunate to have some that generations of families have frequented and that continue to stand the test of time.

THE PASTA FACTORY

The Pasta Factory has been serving some of Columbia's favorite pasta dishes for over four decades. It has changed owners and locations, but many of the original recipes and original décor are still enjoyed by new generations of regulars. It was originally opened in 1976 by two local businessmen, Mike Kroenke and Dennis Harper, in the Crossroads Shopping Center on the western edge of Columbia at that time. In 1980, one of the employees, Otto Maly, purchased the restaurant and relocated it in 1986 to a busy downtown location on the corner of Broadway and Hitt Street in the historic Edwin Stephens Building, which was built in 1892. With this new location, the Pasta Factory was able to add outdoor dining in a New Orleans–style courtyard and a banquet room for private events. It also incorporated booths, ceiling fans, stained-glass signs and the bar from the original location. In 2001, the Pasta Factory changed hands once again, and employees Jason and Jennifer Dubinski became the new owners. They moved the restaurant back to the

The Pasta Factory sign at the downtown location. *Collection of the Dubinski family.*

west end of Broadway in a more suburban area that provided ample free parking, something the downtown location could not offer. The original booths, ceiling fans, stained-glass signs and bar were moved once again and incorporated into the new location to provide continuity and let their regulars know it was still the Pasta Factory, just in a new location.

A lot of the original recipes have been maintained, but there have also been changes over time to accommodate customers' evolving tastes. The Mostaccioli con Salsiccia and Sausage Ziti have remained menu favorites over the years. Jennifer Dubinski says there is a happy hour crowd of regulars. It took some time to make sure that all the downtown customers knew they were still in business, but Jennifer enjoys seeing the familiar faces on a regular basis now.

One of the regulars, Bill Sappington, has been a Pasta Factory customer since it first opened at the Crossroads Shopping Center location. Sappington's family has a long history in Columbia. His grandfather Dot co-founded Central Dairy. Sappington has somewhat of a celebrity status when he arrives every Friday for lunch. He even has an off-menu dish named for him, the Sappington Special. When asked how he got a dish named after him, Sappington chuckled and said, "I kept describing what I wanted and every time I had a new server, I would have to describe it again. Jason [Dubinski] said he was going to name it so I didn't have to describe it every time I ordered it. Now, I just say Sappington Special and they all know what I want." He's not tied to his namesake dish though and sometimes gets what his son orders. The ninety-one-year-old native Columbian drives himself and is often joined by his son Brent or daughter Nancy Sue for his weekly Pasta Factory lunches. Sappington's wife, Sherl, was his lunch date for several years, but she is no longer able to join him. Although he has been retired for several years, he used to work at Shelter Insurance Companies, which was within walking distance of the original location. He was able to walk to the restaurant for lunch and be back to work in time. When he found out that Otto Maly was moving the restaurant downtown and out of walking distance, Bill Sappington told Otto, "You're making a big mistake

Front of postcard announcing the thirtieth anniversary of the Pasta Factory. *Collection of the Dubinski family.*

moving downtown." He says he was joking, but he really didn't want to see his favorite restaurant move.

Of course, he was still going to go to the Pasta Factory. A Shelter Insurance agent had an office with a small parking lot two blocks away from the new downtown location. He gave the Sappingtons a "lifetime parking permit." When that agent retired, the new agent continued the privilege. Sappington would drop his wife off at the Pasta Factory and then park in the nearby lot—no continuously circling the block looking for an open spot! There are many wonderful memories of meals enjoyed during the forty-plus years that the Sappingtons have been customers, but one particular memory stands out for Sappington. In the private banquet room at the downtown location, Bill and Sherl had a sixtieth wedding anniversary celebration with family and friends, and that tops his list as his favorite memory.

Jennifer Dubinski said her favorite things about owning and operating the Pasta Factory have been the friendships she's developed with the staff over the years, hiring local kids and the challenge and excitement of moving to a new location. Jason and Jennifer hope to keep the Pasta Factory going for many more years and for their customers to want to keep coming back because the restaurant is comfortable, the food is good and not too expensive, and the Dubinskis always want everyone to be full when they leave.

G&D STEAKHOUSE

"Hi my friend," "Hey Buddy" or "You, my friend, what you have today?" are common greetings to anyone who steps inside the G&D Steakhouse located in a strip mall on Worley Street, just off Interstate 70. Everyone is a friend at G&D Steakhouse! The Greek family of Gus and Kasiani Aslanidis has been welcoming customers to the family-owned restaurant since 1970. Gus and Kasiani were farmers in Greece in a very rural setting with no running water, electricity or paved roads. They had applied to come to America in the 1950s, but it took ten years for their application to be accepted. In 1966, they gave their four acres of land to Gus's sister, who was remaining in Greece, packed up their four children and got on a boat to America. Gus's son Angelo remembers it was a fourteen-day trip and everyone was seasick. Kasiani's older sister, who had been in Wisconsin since the 1950s, was their sponsor. After living in Wisconsin and Iowa for a few years, Gus and Kasiani moved their family to Columbia in 1968. Kasiani's brother George Terzopolus opened the first G&D Steakhouse on Ninth Street in 1969. The name is from the initials of the original owners, George Terzopolus and Dino Goadas. Gus bought into the G&D Steakhouse located in the strip mall on Worley Street in 1970, and his family has been there ever since. Gus was a fixture at the cash register until his health deteriorated and led to his passing in 2016, but his presence can still be found in the many family photos that adorn the walls in the simple but homey restaurant. Gus and Kasiani's family relations have made a large footprint in Columbia's restaurant scene of past and present, including other G&D Steakhouses, Dino's Steakhouse, Angelo's Restaurant, G&D Pizzeria and Jimmy's Family Steakhouse.

Two of Gus's sons, Angelo and Alex, have taken over the reins at G&D Steakhouse, and many other family members also can be found behind the counter and mingling with customers in the dining area. Kids who came in with their parents decades ago now bring in their own kids and even grandkids. Customers go to G&D as much for the experience and the fun atmosphere as they do the steaks. Angelo said he sometimes has to remind customers, "We're working with family, we talk loud, but we're not fighting. We're Greek. That's what we do." The Aslanidis family likes to have a good time when they work and never miss an opportunity to give a good-natured nickname to a regular. There's "Red," "Curly," "Chicken Man" and "The Professor," to name a few, and often their orders appear without them even having to say what they want. Angelo remembers a time when a clean-shaven man walked up to the counter and looked over the menu, and when

he placed his order, Angelo knew his voice but didn't recognize the person. After studying the man's voice a little longer, he said, "Is your name Phil?" It was a customer who had moved away and hadn't been to G&D for over twenty years. He had eaten at G&D regularly while a student at MU and had sported a full beard at the time. Phil was stunned and said, "How did you recognize me?" Angelo replied, "I didn't, but I knew your voice."

G&D Steakhouse started in 1970 with a simple menu of four different steaks: filet, sirloin, ham steak and hamburger steak. The steaks ranged in price from $0.97 to $1.56 and included a salad, baked potato (those baked potatoes!) and a piece of Texas Toast. The affordable but good steaks continue to be a favorite on the menu, but over time, the menu has evolved

Wall decorations at G&D Steakhouse, including an original 1970 menu. *Author's collection.*

to include, among other items, cheeseburgers, spaghetti, appetizers and different shrimp options. And what makes the G&D baked potatoes so good? Angelo just shrugs his shoulders, smiles and says he gets asked that question all the time. He then offers the only explanation he can come up with: "Wash them, put them in the oven and cook them until they're done." G&D bakes about 1,500 pounds of potatoes a week. What's the secret with the steaks? Angelo says, "We buy good-quality meat and trim it. We don't have a special seasoning. We just cook them, but we can add seasoning if someone requests it. Most don't."

Like his father before him, Angelo has dedicated his life to the restaurant. He arrives early in the morning to start trimming the steaks while leaving just the right amount of fat to add flavor and then doesn't miss the opportunity to get behind the counter for the lunch and dinner crowds. He reflected, "Almost forty-eight years in this place, and it's a part of you. My father didn't have friends outside of the restaurant. We have our customers." Many of the regular customers considered Gus a friend. Chris Andrews-Mcgavock recollected, "My parents went there weekly. When mom passed away he

Gus Aslanidis behind the counter at G&D Steakhouse. *Collection of the Aslanidis family.*

[Gus] sat and talked with dad for a long time and gave him a free meal. A very kind man." The customers range from construction workers to college students to families carrying on the tradition of enjoying the hospitality and budget-friendly meals offered at G&D Steakhouse. Angelo is appreciative of the restaurant's following and says, "If we didn't have product, service and personality, we wouldn't have been here forty-eight years." As one looks around the steakhouse and sees the younger generation of Aslanidises, it seems safe to assume that Gus's legacy will carry on for future Columbians to enjoy. Well done, my friend!

THE HEIDELBERG

In a highly coveted location adjacent to the University of Missouri sits the Heidelberg, or "the Berg," as most have referred to the local hangout since its inception. The location was already well known and attracted many

diners as the Ever Eat Café. This was a mixed blessing for the owners when they opened the Heidelberg in 1963. There was already a following to the location, but there were also high expectations from those who were regulars at the Ever Eat. Originally, there were four owners—George Petrakis, Marty Sigholtz, Jim "Cornbread" Martin and Dick Walls—all already experienced in the restaurant business. Dick Walls bought the other partners out in 1965 and became the sole owner.

The Heidelberg owners knew their target market would be those associated with the adjacent university, and that became the inspiration for the name. Heidelberg, Germany, was the college town that was home to Germany's first university, Heidelberg University. Although the menu included American college student favorites like burgers, sandwiches and pizzas, there were also a few German offerings. Dick Walls remembers they had to find someone who could interpret the recipes because they were written in German. *Gebackener Schinken* (baked ham sandwich), *Cat Fisch Brot* (catfish sandwich) and *Belegates Brot Mit Hackfleisch* (meatloaf sandwich) were some of the more challenging items to read on the menu and were numbered to make ordering easier. Some German options still remain on the menu, but an unofficial but popular Facebook poll would indicate that fried mushrooms, tenderloin sandwiches and, of course, beers were and continue to be the most popular menu items enjoyed at the Heidelberg.

The Berg has been the college hangout for generations of college students, faculty and alumni. Bob Mindlin, a 1969 University of Missouri graduate, remembers his time at the Heidelberg: "There were some great sandwiches at the Heidelberg. On the opposite end of that building was Crane's Barber Shop. I swear, I got more education in that shop than at MU! Add that education to the great meals at the Heidelberg and life was never better." He made a return visit in 2016 and said, "While visiting Columbia this past summer I was in the Heidelberg and I still contend they have the best pork tenderloin sammich going!" Another MU alumni from the late 1960s, Dave Albin, recalled, "If you were a regular at Heidelberg, you had a pewter mug with your initials on it hanging on the wall behind the bar." Recently, a 1980 University of Missouri graduate was dining with his son, a current university student, and said he likes to come back to the Heidelberg every time he visits because "it has a welcome feeling and you can have a drink and talk. Good friends can hang out here." Many remember having nervous conversations over first dates at the Berg that later led to marriage proposals. Cami Ronchetto recollects a 1979 date when she was wearing her trendy footwear: "My

The Heidelberg menu.
Collection of Dick Walls.

first date with my husband of 30 years was at the Heidelberg and I kicked him in the shin with my Dr. Scholl's wood sandals! He still claims to have a scar."

Dick Walls remembers sharing the experience of national events like the Kennedy assassination and the Vietnam War news coverage with his customers while at the bar. It was a place where everyone could feel comfortable among friends in an uncertain time. When the Heidelberg had a special fiftieth-anniversary ribbon-cutting ceremony in 2003, a couple who was tending bar the day President Kennedy got shot made the trip to reminisce and share in the celebration of the restaurant's longevity.

A large part of campus life revolves around MU basketball and football games. The clientele at the Berg is no exception, and they typically are very sports oriented. Many watch parties and celebrations for MU basketball and football have taken place at the Heidelberg. An especially memorable one was when, after a seventy-five-year wait, the Missouri basketball team was ranked first in the nation. Dick Walls, a huge MU sports fan, remembers when the announcement was made on Monday, January 25, 1982, and the celebrating continued until he closed the bar.

The hangout is located about a block away from Jesse Hall on the university campus, where concerts and shows are often held. This has made the Heidelberg a convenient place for performers to hang out and enjoy a drink and some fun after their shows. Dick Walls remembers 1960s musical

folk trio Peter, Paul and Mary hanging out in the bar so long that he finally had to kick them off the pinball machines so he could close.

In 2002, Dick's sons, Richard II "Dickie" and Rusty, bought into the restaurant and took over operating the Heidelberg. During the time that Dick Walls owned the Heidelberg, he also owned several other restaurants in Columbia. The Hofbrau, located at Tenth and Cherry Streets, opened in the summer of 1966 and was destroyed in a 1971 fire. He also owned a barbecue restaurant, the Smokehouse, and downtown restaurant Boone Tavern, but those have both closed as well. However, the Heidelberg has been a mainstay and one that he doesn't see his family letting go of. "I guess we feel like we are part of the university." The Walls family was faced with the decision to let it go when a fire destroyed the building in 2003. When asked why the decision was made to rebuild, Dick Walls said, "It just seemed like the thing to do. We got all kinds of e-mails. We got e-mails from all over the world, for crying out loud. We got e-mails from England and Singapore, J-school students who have been hanging out in there for a long time."

In 1973, the laundromat next door was purchased, and the restaurant expanded. The rebuild after the 2003 fire included a rooftop patio. Despite the changes, it's still a place for decades of customers to revisit their college stomping grounds, hold conversations over a first date and return for later anniversary celebrations.

TONY'S PIZZA PALACE

The walls are decorated with landscapes from Greece and a few black-and-white family photos, the smell of freshly baked pizza is in the air and if you're there early enough, you'll see the matriarch of the family finishing her inspection of the place and making sure everything is ready for the day. You have arrived at one of the oldest family-owned restaurants in Columbia, Tony's Pizza Palace. The home of "the best gyros in town," according to co-owner Pete Veros and many loyal customers, is located on the corner of Walnut and Fifth Streets in the downtown area.

The Veros family originated in Greece, but after the Greek economy was devastated after World War II, they had to find jobs elsewhere. Tony and Asimina were working in a watch factory in Switzerland when Asimina's brother asked them to come to the United States to work in a restaurant he had opened in 1959. Her brother was Jimmy Kardon, who is known

in Columbia as the owner of Rome Pizzeria, which closed in 1996 after a thirty-year run. The Veroses arrived in the early 1960s and by the early 1970s had purchased Jimmy's original restaurant and changed the name to Tony's Pizza Palace. Tony's was originally in a building on Broadway, but it has been in its current location since about 1980. It changed ownership once but remained within the extended family. Tony and Asimina Veros bought it back in the late 1980s. Tony passed away in 1988, and Asimina and her three sons, Pete, Daniel and Steve, remain the owners. Asimina, Pete and Daniel run the restaurant.

The current location is very historic aside from the half-a-century-old restaurant that occupies it. It is the last remaining building of the Sharp End, the city's black business district during the time of segregation. It received the most notable properties designation in 2017. The building is owned by Ed Tibbs, whose father was the original owner. Ed is not only Tony's landlord, but he and his wife are frequent customers as well. Why do they keep going back? Ed says, "The food and the relationship we have with the family. We're like family. They were tenants when my dad owned the building, so I've known them forever."

When asked what sets them apart from other pizza places, Pete Veros says, "We use family recipes, and everything is homemade. We make our sausage, ground beef with spices, dough, pizza sauce and tzatziki." Pete says his tzatziki, or cucumber sauce, is what helps make his gyros the best. He also uses it as a salad dressing. Tony's makes a traditional thin-crust pizza that has created a loyal following. Bea Vittoria has been a Tony's fan for decades and sums up why she keeps going back: "Tony's still makes the same type of thin crust greasy cheesy heaven today. There's just something about that pizza." Over the years, they have added a few sandwiches to the menu, but it's not their goal to have a lot of menu items. "We do what we do really well and don't want to venture into too many things." Pete continued, "The basic pepperoni and sausage pizzas, gyros and the Greek dressing are what get ordered the most." Some folks can't decide what their favorite is. Torie Brown wrote, "I go there at least two times when I'm in town, once for a gyro and the other time for pizza." Another regular is Elton Fay, whose office has been next door to Tony's Pizza Palace for almost twenty years. He's been eating there for over thirty years though. Elton is a fan of the gyro and mushroom pizza, and if he's feeling adventurous, he adds green olives. He shares why he keeps going back: "People are friendly, good hometown atmosphere and the food is good. If food's good, you go back!" If you want to try one of Pete's favorites, order the souvlaki sandwich.

Owner Pete Veros cutting a pizza at Tony's Pizza Palace. *Author's collection.*

Tony's Pizza Palace, Fifth and Walnut Street. *Author's collection.*

Pete Veros has literally grown up at Tony's Pizza Palace and remembers riding his bike in the large vacant area upstairs of the first location with his brothers and running around in the kitchen and dining room. He says, "It's satisfying to see the business grow and be a part of the local community." There isn't a specific demographic of their customers. They have many longtime repeat customers, families, construction workers on their lunch break, downtown business owners and professionals—basically anyone who likes good pizza. Why do people keep coming back to Tony's Pizza Palace? Based on feedback Pete gets from his regulars, he answers, "Good food, best pizza, feel comfortable when they're here, very relaxed atmosphere, inexpensive for families and they like seeing the owners here."

MUGS UP DRIVE IN

Since 1955, Mugs Up has been serving Zip burgers to its drive-in customers, and the tradition continues over sixty years later. Ray Kewley didn't grow up in Columbia, but he definitely left his legacy in the mid-Missouri town. Ray grew up during the Great Depression and moved around the country looking for work before he met his wife, Edna, in Indiana. They moved to Texas and then eventually found their way to Columbia. An older couple looking to retire originally owned the restaurant for a few months. Ray and Edna saw it as an opportunity to own their own business, and the rest is history—lots of history! Mugs Up was a chain of restaurants in the 1950s, with sixty franchises countrywide. There are only two remaining, and the Columbia location is the oldest. An Independence, Missouri Mugs Up has been in business since 1956. They are no longer franchises; each is independently owned. Although they have similar menus, they each have their own unique recipes.

Ray's original recipes for chili and root beer have been passed down from generation to generation and are still made every day. Ray managed the restaurant for decades and then handed it over to his son Larry and Larry's wife, Kay, in 1974. Kay and Larry were Hickman High School classmates, and Kay started working as a carhop at Mugs Up when she was fifteen. Larry and Kay married in 1968, and it was a natural transition when they took over the business. Even when Ray wasn't technically "in charge" anymore, he couldn't stay away and worked every day until he was eighty-three. He passed away in 2007. Larry and Kay carried on the tradition and

raised their own children, Brandon and Katie, alongside them as they prepared the classic Zip burgers, chili cheese dogs and, of course, the homemade root beer. Brandon's favorite childhood memories revolve around the time he spent at Mugs Up. He loved working with his Grandpa Ray and remembers being very proud of himself when he was first allowed to run the register when he was just twelve years old. Katie no longer lives in Columbia, but Brandon has now taken the reins from his parents and can't see himself doing anything else. He says, "I feel connected to the staff and memories that continue to be built."

Many of the current carhops have twenty-plus years of experience at Mugs Up, including Kelli Bias, whose three daughters have also worked at Mugs Up. Taking a quick break on a warm and busy day at the drive-in, Kelli was giving her feet a break and sat on an upside-down bucket in the back of the small building. She looked tired after just finishing the lunch rush but perked right up when asked why she has stayed at Mugs Up so

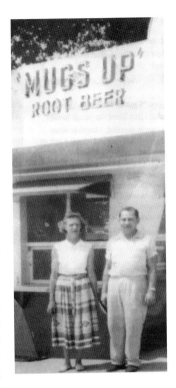

Mugs Up Drive In owners Ray and Edna Kewley in the 1950s. *Collection of Kewley family.*

long: "I enjoy the customers and wouldn't trade my bosses for nothing. It's a wonderful place to work." Brandon grew up with a lot of the current staff and considers them family. Many of the staff's children now work at Mugs Up. The Kewley family and many of the employees have vacationed with each other and celebrated with many birthday parties and baby showers. A peek inside the very small quarters of the Mugs Up building where all the food is prepared reveals walls covered in photos of the Kewley family intermingled with different staff and their children and even grandchildren.

A warm day ensures a full parking lot at Mugs Up. It hasn't always been at its current location, but that didn't stop loyal customers from following the restaurant. It was originally on the heavily traveled Highway 40, now Business Loop 70. In 1969, Tennessee Jed's Barbeque wanted to rent its location, so Ray decided to move the entire building and business about a block west of the original location to 603 Orange Street, where it remains today. This took his carhops out of heavy traffic, but it also put the business

in a neighborhood with no visibility from a main road. Brandon Kewley said his grandpa wasn't worried about the move. He just said, "The people that had been following us for years just followed us back." Brandon said they have such a local following because "people have really good memories. It's a time warp where people revisit the past. Things haven't really changed; most of the same staff and carhops have been here a long time." He went on to say, "It's a reminder of the way things used to be when people knew each other and sat on their front porches." Locals and former locals agree that the nostalgia, along with the simple food that remains a constant from the past, is what keeps them coming back. Laura Willis Getty, who grew up in Columbia in the 1960s and '70s but moved away in the 1990s, reflected, "Going to Mugs Up was going 'out to eat' when I was a kid. Kid-sized mugs of root beer. Tray on the window of the 1960 Rambler station wagon. Tooting the horn to have the carhop come for a new order or to take the window tray." Customer Steve Riegert agrees and wrote, "Nostalgia is good, yes. I lived in Columbia for 30 years. Been gone for 15. I am in Columbia frequently....When in town at lunchtime, many times I go there. The owners, servers and nostalgia are great. If you like that type of food, which I do, the food is great! Keep it up!"

It's been a family tradition for another local, Cathy Perkins, who says, "My mom and her sisters worked there as teenagers for 50¢ an hour, of course movies were a dime back then. I've been going since I was about three with my uncle, been going my whole life and won't ever stop!"

Other than the location and the addition of French fries in the 1980s, little has changed at Mugs Up. They still only accept cash and local checks for payment, the menu is still on a large sign on the side of the building and they still are only open seasonally from early spring to about Halloween. This gives everyone who works there time to rest and spend time traveling and doing all the things that the warm months keep them too busy to do. It also gives their regular customers a chance to miss them. Brandon doesn't advertise and relies on word of mouth and social media to keep customers coming. A lot of social media buzz is created when the announcement of opening day in the spring is made. The most frequently ordered items continue to be the cheese Zip, chili cheese dog and root beer. Ray Kewley's original chili recipe has a strong presence on the menu: chili cheese Zip, chili dog, chili cheese dog, chili bun, chili cheese bun, chili cheese chips, chili cheese fries, extra chili-any way you want chili, Mugs Up can serve it to you. When asked if he ever gets tired of the food, Brandon quickly replies, "Absolutely not! I eat a Zip burger every day."

SHAKESPEARE'S PIZZA

Shakespeare's Pizza has been a favorite of college students since 1973. What has now become a Columbia pizza empire, offering three locations with a booming frozen pizza division, began as carry-out and delivery only. The original location was in a small building on the corner of Ninth and Elm Streets, conveniently adjacent to the University of Missouri campus. Jay and Nancy Lewis purchased the business in 1976 so Jay would have some place to work. When Shakespeare's first opened, the University of Missouri dorms didn't serve meals on Sundays, so Sundays were a huge day for deliveries when school was in session. Jay would close Shakespeare's in the summers back then and spend his summers farming soybeans and wheat. Kurt Mirtsching, who has become part owner and manages all operations, began as a delivery driver in 1978. Jay Lewis passed away in 2016, but Nancy and Kurt are continuing to build the business that Jay envisioned. Nancy Lewis is a local who grew up in Columbia and has a sense of pride in owning something that is so engrained and beloved in her hometown community. Her and Jay's daughter, Alycia Lewis, grew up in the restaurant and now works for the business.

There are aspects of Shakespeare's that are unique to the local pizza hangout and immediately recognizable to anyone who has enjoyed pizza there. When Jay and Nancy Lewis first bought Shakespeare's, money was tight, and the décor consisted of the cheapest material they could find. Apparently, wood car siding was fairly inexpensive at the time, and along with the existing brick, that became the walls. The theme was carried over when both new locations were built. There's also the signature plastic Shakespeare's cup that serves as the glassware in college student apartments all over Columbia. Most locals have a stack in their kitchen cabinets as well. Instead of paper napkins, stacks of terrycloth washcloths are found next to the silverware bins in each restaurant. A favorite of local children are the balls of dough that the pizza makers throw over the glass walls to them. The kids *and* their parents appreciate the entertainment that the dough provides while they wait for their pizza.

The Meat Lover's pizza is very popular, but with about thirty toppings available, anyone can have whatever kind of pizza they like. Chris Niedner isn't a local, but he shared why he visits Shakespeare's whenever he can:

I live in Kansas City and every time we go through Columbia I like to stop at Shakespeare's Pizza. I've been going there for about twenty years, after

Shakespeare's Pizza kitchen downtown. *Collection of Kurt Mirtsching.*

hearing some friends from Mizzou rave about it. The downtown location has a great atmosphere and has the feel of a college bar or hangout. The pizza itself is delicious. The sauce is what gives it a unique taste, I think. I've been trying to think of a similar pizza in KC, but I can't. We usually keep it pretty basic with the toppings, but one of these days I'd like to try some of the more adventurous choices. They all look delicious.

Shakespeare's used to offer sandwiches, but they were phased out. Salads showed up in the early 2000s and are very popular, especially downtown, according to Kurt. Of course, pizzas are the main draw, and Shakespeare's uses about nine thousand pounds of cheese and two and a half semi-trucks full of other ingredients on a weekly basis.

Shakespeare's connection with college students has remained a constant, and one of the owners' favorite events to participate in is the University of Missouri Freshman Walk. Every year since 1995, at the beginning of the fall semester, Mizzou freshmen gather on Francis Quadrangle to run through the freestanding Columns to Jesse Hall to symbolize their entrance into Mizzou. For over a decade, once the students run to Jesse Hall, they turn back around and run to nearby Shakespeare's for a free slice of pizza. The line literally wraps around the entire block.

Shakespeare's has seen a change in its customer base over time. It started with mostly college students. Then, as adjacent buildings became available, the restaurant expanded and eventually added a parking lot, which attracted more locals, and Shakespeare's became a "Columbia thing." Downtown Columbia has seen an influx—some would say a takeover or invasion—of

MU freshmen lining up for free pizza at Shakespeare's. *Collection of Kurt Mirtsching.*

luxury student high-rise apartments, which has increased the number of students finding their way to the downtown Shakespeare's. Two additional locations closer to family residential areas have given other options with easier parking for locals.

One high-rise student apartment building in particular had a large impact on Shakespeare's and had the local pizza-loving community and MU alumni living afar in an uproar. The folks at Shakespeare's like to have fun with their promotions and social media. As an example, one of the latest Facebook promotions included a prize package to the winner of "a Shakespeare's shirt, a shot (if you are 21 and not too hung-over), a glazed donut and a gift card for $62.58." So when on April 1, 2015, Shakespeare's Facebook page announced that it was temporarily relocating its flagship downtown restaurant so the current building could be demolished and replaced with a new development, most thought it was an April Fools' prank. The story was reported in Kansas City and St. Louis media outlets and spread quickly to alumni living in those areas. No one wanted to believe that their beloved college hangout, a landmark in downtown Columbia for over forty years, could be no more! The facts were sorted out, and fears were calmed. The owners of the building had sold to a developer who was going to replace the current Shakespeare's building with yet another high-rise apartment building downtown. To the delight and relief of college students, alumni

and locals, a deal was worked out so that Shakespeare's would have a fifty-year lease to return to the street-level space it had occupied for as long as most of them could remember once the building was completed.

Fortunately, there was an unoccupied former restaurant space just around the corner, so "Tempspeare's" could temporarily relocate and continue its pizza and bar operation. In order to maintain as much of the original look and feel of Shakespeare's when it reopened, Shakespeare's let its followers know "we've meticulously cataloged our space—measuring and photographing our bricks, wood car siding, antique signs and booths—so we can recreate the Shakespeare's atmosphere that people know and love. We'll bring back the original ovens that give our crust that special crunch, the same dough machine will keep cranking out tons of dough, we'll even keep the same sinks where we hand-wash more than a thousand dishes every day." Some changes were made to meet current building codes, and they put the same bricks back in the restaurant except for the new larger party room. Sadly, owner Jay Lewis passed away before the reopening, but on August 5, 2016, the new and bigger Shakespeare's opened its doors. The meticulous work that went into preserving the original look and feel of the space was a success. One customer wrote, "I walked into the new Shakespeare's and walked back in time….Wow." Kurt Mirtsching was quoted in a local paper about the whole process saying, "We've been mad about it, excited for the new building, nostalgic and sentimental about our time in the original building. The experience has taught us that Shakespeare's isn't just about the building. It's about the people inside."

THE BROADWAY DINER

The restaurant with the neon DINER sign on top has been known as the Broadway Diner since 1989, but the prefabricated building has been used to serve made-from-scratch comfort foods in many different locations around the city since the 1960s. The current building replaced a smaller prefabricated diner from 1949. Valentine Manufacturing Company out of Wichita, Kansas, made both buildings and advertised them as "portable steel sandwich shops." The company is no longer in business, but the current Broadway Diner building is said to be the last remaining operating Valentine diner west of the Mississippi.

David Johnson is the current operator of the Broadway Diner and grew up working in the diner and surrounded by its history. Keeping track of all the owners and locations can get confusing, so David shared the story of the metal building. The original diner opened in the smaller building, which had ten stools at the counter in 1949 as the Minute Inn and was owned by Hubert Blakemore. In the late 1950s, he sold it to Rex and Marie Freemeyer, who replaced the original building with the newer, larger building in the early 1960s. The newer model included booth seating and arrived in two pieces. It moved around the area and operated from several different locations on both Providence Road and Broadway. The final place it landed as the Minute Inn was 218 East Broadway in 1961. In 1979, Gordon and Fran Meredith purchased it and changed the name to Fran's Diner. Ed Johnson, David's father, purchased it from the Merediths in 1989 and changed the name to Broadway Diner. In 2001, Ed loaded up the diner on a trailer and moved it about a block east to where it sits today at 22 South Fourth Street. Ed's son David now operates the historic diner.

When Ed purchased the diner from the Merediths, he already had experience managing several restaurants, as well as owning another historic diner in Columbia, Guy's Diner, located on North Garth Avenue across from what was Ellis Fischel Cancer Hospital. He purchased Guy's from Guy Wright in 1977 and owned it until 1985. One customer remembers that Ed was referred to as Guy so many times that he displayed a sign on the counter that said, "My name is NOT Guy." Ed continued the following that Guy had built from locals as well as patients' families from the hospital across the street. Many of the patients were at Ellis Fischel for long periods of time or had many return visits, so their families would frequent Guy's Diner. On holidays, the hospital cafeteria wasn't open, so Ed and his wife, Velma, would make pies, turkey/ham and all the sides for the families. Ed's son David shared, "Dad got so attached to the families at the old cancer hospital. Seems like we often had either extra folks for holiday meals or he would take whole dinners to families at the hospital." Guy's Diner was known for brain sandwiches, pork tenderloin and egg sandwiches and standing-room-only crowds. A car dealership bought the land where Guy's sat, and Ed decided to sell the building and spent some time working at other Columbia restaurants before realizing he wanted to work for himself again.

Fran's Diner, and the Minute Inn before it, already had a following from the late-night after-bars crowd when Ed Johnson purchased it in 1989, but Ed wanted to increase the day crowd. Many college alumni still reminisce about the biscuits and gravy they had at Fran's after the bars closed. Ed's

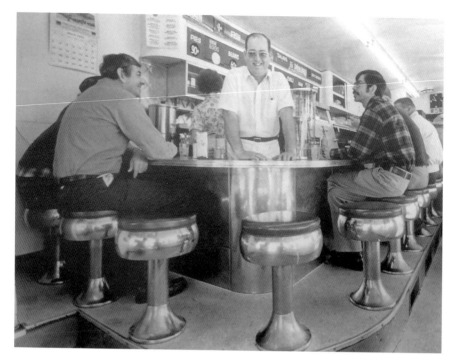

Owner Ed Johnson behind the Guy's Diner counter in 1985. *Collection of the Ed Johnson family.*

vision was to capitalize on what set the authentic diner building apart from other Columbia restaurants, and he added a few aesthetic touches to give it that visual image. Quilted stainless-steel panels were added to the exterior, and the neon DINER sign was added to the roof. Those touches, along with the counter stools, vinyl booths, personal service, simple home-style cooking and breakfast anytime, provided the full diner experience. Of course, a good diner has to have good diner food, and the Broadway Diner has not disappointed with its stick-to-your-ribs menu choices.

When it comes to food, the Broadway Diner is best known for "The Stretch," a plate full of hash browns topped with scrambled eggs, chili, cheddar cheese, green peppers and onions. The Stretch originated when the diner was the Minute Inn, and the dish became known as the cure for a hangover, which is a common ailment in a college town. "Matt's Dilemma" takes the Stretch to another level by covering it in sausage gravy topped off with sausage or bacon. A favorite burger is "When Worlds Collide," a bacon double cheeseburger royale (a sunny egg on the burger) served on a homemade donut. David says the recipes used in the diner are from a variety

of sources: "The chili is adapted from the original diner recipe, the gravy and doughnuts from Grandma, the cinnamon rolls from Mom." David creates the soups and different specials offered. His wife finds dessert recipes online and in cookbooks, and then they "dinerize" them.

People don't keep going back to Broadway Diner just for the food though. Ed Johnson once said, "It's a place to catch up on community gossip and social events, where customers care about the health and welfare of employees and vice versa. When you've been in a close-knit community-based business for twenty years, you develop many friends." Ed and David Johnson have referred to the diner as "Columbia's kitchen table" because of the clientele that frequents there. Families, retirees, professors, students, professionals, city officials, postal workers and electricians all feel welcome at the diner. Ed was quoted in 2009 as saying, "You do not have to be invited to participate in conversations three tables away. You just jump in, and if they don't like it they'll say 'Shut up' or change the conversation." David Johnson also enjoys the sense of community that the diner provides. He enjoys introducing strangers and connecting diners by inviting them to enjoy a meal together at the large corner booth. If someone acts hesitant, David just smiles and assures them, "I only let the best people in here, so it's OK." More often than not, customers accept his offer and end up with new friends by the time they leave.

Although David grew up working in his dad's diners, he didn't become fully involved in the operation of Broadway Diner until his brother Michael was killed in a car accident in 1995. The Johnson family worked together at the diner to support one another while they were grieving and dealing with the sudden and unexpected loss. Later, Ed was diagnosed with Parkinson's disease and eventually was physically unable to keep up with the demands of running the diner, so David took over in 2011. David said, "I feel blessed to take over something that the people before loved with their heart and soul."

A move in 2001, prompted by the building of a Walgreens store on the spot that the diner had occupied since 1961, was a changing point in the life of the Valentine diner. At 1:00 a.m. on a hot summer night in August 2001, the diner was loaded on a tractor-trailer, and in twenty-two minutes it was in its new home on the corner of Fourth and Cherry Streets. David Johnson says the Broadway Diner experienced "a huge difference in business after moving; it didn't seem like the other side of Providence [the original location] was part of downtown. Being closer to student housing is bringing in new customers." The new location is also close to the heavily traveled MKT nature and fitness trail, a former connector of the Katy Trail, the

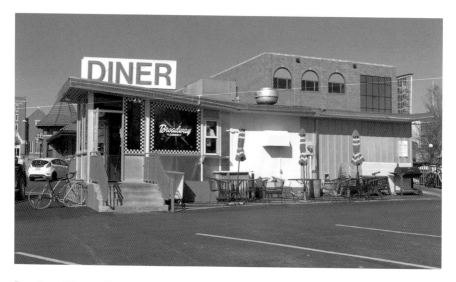

Broadway Diner at Fourth and Cherry Streets. *Author's collection.*

longest rail trail in the United States. David enjoys the diner "being the Gateway to Columbia through the trail system and meeting people from all over the country that venture off the trailhead and stumble upon the Broadway Diner." The new location allowed for a much-needed expansion to the original building by adding additional seating, as well as outdoor seating space.

No matter the location or the name given to the 1960s metal building and its 1949 predecessor, the diner has continued to provide generations of hungry guests a nostalgic place to feel welcome and enjoy home-cooked meals. As long as David Johnson is the keeper of the Columbia tradition, he says it's his goal "to try to make everybody's day better with a happy start and some good food."

Ernie's Café & Steak House and Booche's Billiard Hall

Over Two Hundred Years of Combined Service to Columbia

Two restaurants that are considered classic must-visit eateries immediately come to mind when visitors come to town and ask where they should eat. Booche's and Ernie's are the common responses by locals. Columbia has had several hundreds of restaurants come and go since its inception, but these two have the distinction of holding the record for being in operation longer than any other restaurants in Columbia history. Both have had several owners who consider themselves caretakers of a local legend, and both have continued to serve the food that made Columbia fall in love with them from the beginning. Booche's Billiard Hall has been in continuous operation since 1884, and Ernie's comes in as second oldest, having been on the Columbia restaurant scene since 1934. One customer who has moved away from Columbia summed up her love of Columbia and its two oldest restaurants. She wrote, "I miss everything about Columbia!! The vibe, the friendships, the culture, the sense of community, breakfast at Ernie's, and burgers at Booches!!! And everything in between!"

ERNIE'S CAFÉ & STEAK HOUSE

Ernie's was originally opened in 1934 on the corner of Garth and Highway 40 by Ernie Lewis under the name Ernie's BBQ. He wanted to put his experience from working the grill at his stepbrother's place, Ralph's Drive

Inn, to work for his own business. He remained in this location until a new small building with only nine stools was built at 208 South Ninth Street. It was from this location that Ernie's became known for his barbecue sauce and his steam-fried hamburger, the "chopped cow," which continues to be synonymous with Ernie's today. After a few years on South Ninth, Ernie Lewis's father-in-law, Mr. Creber, who owned Creber Wholesale Grocery Company on North Walnut Street, provided Ernie with the building that has become an anchor of the North Village Art District in downtown Columbia.

The owners and the décor at Ernie's have changed over the years, but a constant in the café has been a framed drawing by Dick Tracy comic strip creator Chester Gould. Gould was visiting his daughter in the 1940s while she attended college in Columbia, and she took him to Ernie's during his visit. Ernie served Gould a chopped cow, and the chopped cow made it into one of Chester Gould's nationally syndicated Dick Tracy comic strips. The enlarged framed cartoon inscribed, "To Ernie and his Delicious Chopped Cow! Yum Yum!" continues to be proudly displayed above the kitchen entrance. Diners can also get a closer look at a smaller version featured on the Ernie's menu.

In 1949, Ernie Lewis and his family moved to California, and Charlie Christman, who had worked with Ernie at Ralph's Drive Inn, and his wife, Lula Mae, became the new operators of Ernie's. The Christmans lived upstairs from the restaurant. They kept the chopped cow but expanded the menu with "steak and shrimp, sausage with pecan waffles, and home-baked pies." Longtime locals recall a tragic event associated with the Christmans' time owning Ernie's. In 1950, their thirteen-year-old daughter, Janett, was brutally murdered one night while babysitting. The main suspect died in 2006, and the murder remains unsolved. Perhaps Ernie's was a needed distraction from grief for the Christmans.

The Christmans closed Ernie's every summer for cleaning and remodeling and sent postcards to their regular customers the week before the first breakfast of the school year. The Christmans transformed Ernie's BBQ hangout into Ernie's Steak House. On Sundays, more than half of the breakfast crowd came from services at First Christian Church across the street. One of the waiters from the early 1960s recalled that the Stephens girls would come in on weekends, and the boys from the university would come in to look at them. Sixteen years after leaving Ernie's Café, Lula Mae was quoted as saying, "I loved the people and the kids and everything about it. We had beautiful murals on the walls then. We always had soft colors, and we tried to make everything pleasant and serene."

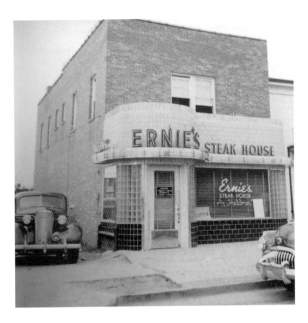

Ernie's Steak House on Walnut Street. *State Historical Society of Missouri.*

Wayne Gladney bought the café in 1963. Another transformation took place under Gladney's ownership. According to Wayne's daughters, Rebecca Fahrendorf and Suzanne Gladney, he loved owning restaurants and offering new concepts. In addition to Ernie's, Wayne managed Topic Café and owned Max's Campus Snack, G&G Dairy Store, Columbia Do-Nut Co., Farmer's Café, Midwest Skelly Restaurant, Maison de Boeuf, Salt and Pepper Lounge and even Zesto Ice Cream briefly. When Wayne purchased Ernie's, the dining area had seating for about seventy-five. Wayne wanted to increase seating and offer a more upscale dining experience, so he installed a dumbwaiter, replaced the two apartments upstairs and introduced the "Pyramid Room" with seating for sixty as a new addition to Ernie's Steak House. The Pyramid Room was popular with nearby Stephens College students and their visiting parents and was usually only open in the evening but provided extra seating for busy MU home football game weekends. Signing their name and the date in the dumbwaiter shaft became a rite of passage for employees. Wayne's granddaughter Charlie Graznak remembers when she worked at Ernie's in 1988 and finally had the chance to add her name. Her coworkers held onto her legs and lowered her into the shaft with a flashlight in one hand and a Sharpie marker in the other. She shone the flashlight on the spot where she was going to add her name, and coincidentally, her mother's name was located in the same spot!

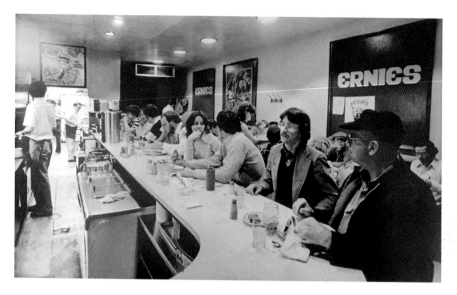

Ernie's interior with then owner Wayne Gladney behind the counter. *Collection of Wayne Gladney family.*

Wayne's daughters, along with their mother, Betty June, worked many hours in Ernie's, especially when they lived in the small house next door. It was convenient for Wayne to recruit his wife and daughters any time he was short-staffed at the restaurant, so his daughters were very relieved when the family moved to a house farther away. Rebecca and Suzanne remember a busy Saturday when Ernie's was packed with a big MU football crowd and a fire broke out. Everyone had to vacate the building, but no one wanted to abandon their food. The sidewalk across the street became full of Ernie's patrons holding their dishes and finishing their meals. After they were done eating, they paid and dropped their dirty dishes in a bucket. The daughters remember their front porch being covered with plates, bowls and utensils the next morning.

Wayne enjoyed the interaction with his customers, but when a line was forming and there were "squatters," he wouldn't hesitate to yell, "Paying customers are waiting!" He became familiar with the regulars and would start working on their orders as soon as he saw them come through the door. Rebecca remembers him telling the story of a trip to Hawaii with his wife after he retired. He ran into one of the regulars from Ernie's and couldn't remember his name but immediately remembered what he always ordered.

There was one event from the diner that always haunted Wayne. One of his waitresses, Becky Doisy, went missing on August 5, 1976. She had

talked about a customer who kept bothering her and making her feel uneasy. She left work a little later than normal and then disappeared. Wayne later regretted not walking her to her car. The police were convinced she ran away and dropped the search for her. Those who worked with her knew that she wouldn't do that and feared foul play. Another employee, Arthur Koch, was a teenager with a crush on Becky, and her disappearance left an impression on him also. He did a sketch of Ernie's, including Wayne and many of the regulars at the time. He also included the Chester Gould drawing on the wall but changed Dick Tracy's words to "Who killed Becky Doisy?" to keep her memory alive. Arthur went on to become an established artist in California and owns a gallery and frame shop in San Francisco. Over time, there were developments in the missing person's case, eventually leading to the arrest of Becky's murderer thirty-three years later. Unfortunately, Wayne Gladney passed away in 2011 before the mystery was solved.

Arthur Koch grew up in Columbia and worked for several restaurants during high school and college. During his time at Ernie's, he learned how to make the popular Roquefort and French dressing from scratch

Sketch of Ernie's Steak House by artist and former Ernie's employee Arthur Koch. *Collection of Arthur Koch.*

and parboil potatoes for hash browns. He later connected with another Columbian, Lisa Balsamo, who is now his partner. Her father ran the University Fruit Company, and her brothers delivered produce to Wayne at Ernie's. They remember he had high standards and would return anything that wasn't perfect. Arthur worked at Ernie's for the next owners and remembers them telling him if he ever had any questions to ask himself "What would Wayne do?" and he still does that to this day. He also remembers Wayne coming in every day at opening and reminding him how to do things "Wayne's way."

Kevin Laws and Marty Fryer bought Ernie's from Wayne in 1977 and made few changes during their ownership. In August 1996, after a weekend spent looking over five years' worth of records and a handshake while touring the basement for a final walk-through, Tom Spurling became the owner of the landmark restaurant. He turned the upstairs back into an apartment and did away with the dumbwaiter, and Ernie's Steak House became Ernie's Café & Steak House. The long counter with a row of stools remains the same as it has for decades. The booths, tables and chairs, along with the Dick Tracy wall hanging, remain as well. Tom has given the place a face-lift to emphasize a nostalgic diner feel. There are vintage pieces throughout the space, the booths have been recovered in bright fabric and the exterior has been refaced in the original Art Deco style. Ernie's continues to be a popular spot with lines out the door during busy weekends and breakfast time, so Tom says one of the best things he's done is switch from one door to two doors, each designated as either entrance or exit, to help with the flow in the small space.

The food at Ernie's is legendary, but so is the wait staff. Joe Newberry tells a story that he remembers from one of his visits in the early 1980s:

Ernie's was known for a wait staff that took no guff from the clientele, but regulars could be pretty hard on a new waitress. One young woman was being run ragged on her first day by a table of breakfast diners, who had stayed through the morning drinking coffee until it was time to order lunch. Requests for more cream for the coffee, menus, anything they could think of. She put out silverware for a table and one of the men yelled, "Hey, my spoon is dirty." The waitress walked right up to him, took the spoon out of his hand, looked at it and replied, "Well, that's about as clean as you're going to get," and threw it on the table, to shouts of approval from onlookers, witnessing the birth of an Ernie's waitress.

Tom Spurling realizes the importance his staff plays in the success of Ernie's and said, "My staff becomes my family, and I put them over customers. If employees are happy and well trained, customers will be happy." Like the owners before, Tom's family has also worked at Ernie's. Both of his daughters, Nicole and Rachel, have worked there. Nicole worked there for six years, and he fired her three times. No nepotism there! He considers his biggest success "being able to raise a family through the business and teach my children responsibility, respect and work ethic that will serve them the rest of their lives."

The chopped cow and number 11 (choice of bacon, ham or sausage; short stack or French toast; with two eggs and hash browns) on the breakfast menu are the most often ordered items. In nice weather, it's not uncommon to see a full house inside and on the outdoor front patio area. Those crowds go through about four thousand eggs per week. Tom enjoys the relationships he's built with customers and estimates that 90 percent of Ernie's customers are regulars.

Tom Spurling is the fifth owner of Ernie's and has the longest tenure of all the owners. He was quoted in 2017 about being one of the owners. "I'm the caretaker," he said. "It's a landmark. It's an important part of the community." Tom's secret for his success with Ernie's? "When you do something, don't do it for money. It's about the love and instant gratification that you get when you feed someone better than they can feed themselves, and not just be fed, but have an experience."

BOOCHE'S BILLIARD HALL

In contrast to the many changes in décor at Ernie's, Booche's has maintained the same "ambiance" (as current owner Rick Robertson calls it) since it opened for business in 1884. The dining area is full of old wooden tables and chairs, vintage photos dating back to the 1800s adorn the walls, pool tables are lined up in the rear of the space and a pay phone hangs on the wall. Burgers are served on wax paper, and there's not a credit card machine in sight—cash only. Though technically not a restaurant when it began in the 1800s, it has been a gathering place for locals and college students throughout its existence. A vintage sign on the wall states, "Booches—Feasting, Imbibing, Debauchery." One change found in researching the history of the iconic hangout is the many spellings of Booche's. P.B. Venable's obituary refers to

him as Booch, a 1980 article refers to it as Boochi's and within the walls and on the windows of the restaurant both Booches and Booche's can be found. Rick Robertson says the official name is Booche's. The different spellings just add to the eclectic charm of the place.

Paul "Booch" Venable, who arrived in Columbia as an infant in 1867, founded Booche's. According to his obituary, P.B. was nicknamed by one of his father's friends after one of Napoleon's generals. After attending the University of Missouri for two years, he and his father opened Booche's Pool and Billiard Hall in 1884. Between 1884 and 1911, Booche's moved to four different locations along Broadway. In 1911, it moved to the second floor of the Virginia Building on South Ninth Street, where it shared space with Tiger Barber Shop. A pool hall and barbershop—what better place to catch up on the town news and share a few fish stories! It was at this location that non-perishable food such as country ham started being offered. Booch passed away unexpectedly at the age of forty-six, but his legacy has continued. In 1927, Booche's made the move across the street to where you can find it today at 110 South Ninth Street. This location included a grill, and the Booche's burger was introduced to Columbia.

Different owners have been the "caretakers" of Booche's since the founder's passing. It was originally left to P.B. Venable's three children, under the management of B.F. Venable. In the 1950s, it was owned by Earl and Leonard Morris, in the 1970s Jerry Dethrow was the owner and current owners Rick Robertson and Charles Kurre took the helm in 2004, after both being employees first. Paul B. Venable's obituary that hangs on the walls of Booche's states, "Booch had always conducted his hall in a manner above reproach, many times advising students to spend less money and time with him and to give more of their time to their school work. He allowed no gambling of any kind." Over the years, the billiards hall policies have reflected the climate at the time and didn't allow women until the 1970s.

It's definitely a family-friendly atmosphere now, and at any given time, the old wooden chairs are filled with college students, blue-collar workers, white-collar workers, families and anyone else who enjoys a classic Booche's burger. Rick enjoys getting to visit with a lot of different people. However, he has noticed a change with the influx of student housing downtown and fewer parking options. "Folks don't want to come downtown as much anymore; we get more people in that are oriented downtown." When asked if there are any plans for a second location, Rick replies with a simple, "Nope. Have had asks, but how do you replicate this place?"

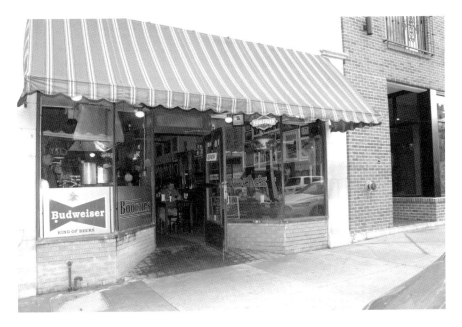

Booche's location since 1927. *Author's collection.*

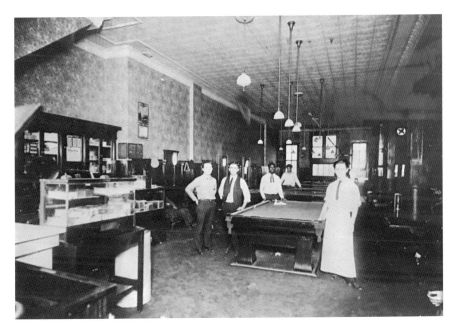

1920s Booche's pool hall in the Virginia Building. *Collection of Booche's owners.*

Booche's burgers. *Author's collection.*

Many regulars can't imagine giving up their Booche's addiction. Susan Toalson Hayden wrote that Booche's is "still one of our favs! My husband played pool there in the 60s and I've been eating there for years. The cheeseburgers are the best! We're never disappointed." Lifetime Columbian Shelly DeVore shared why her family continue to be regulars: "Booche's is the kind of place where you can just 'show up.' Whether you have a business meeting with high powered executives, you're wearing your boots and jeans, headed to a date night at a country music concert or you just got done with ball games, are covered in ball field dirt and need to feed the family, Booche's is the perfect choice. Their simple menu is refreshing with only a few choices meaning you don't have to grapple with yet another decision in a world where our days are filled with thousands of decisions."

Locals, visitors, alumni in town for a game, an occasional ESPN sports reporter covering an MU football game—they can all be counted as loyal fans of the classic but simple burger served on wax paper. Rick Robertson chalks up all the repeat business to the fact that "it's been around for such a long time, when they come back, they like to go back to places of the past. I also like to think we put out a good product and give good service."

Columbia's Next Generation of Iconic Restaurants

W hat began with a small number of taverns serving westward travelers and pioneers in the new town of Columbia has grown into a diverse culinary scene offering international favorites, specialty foods, upscale cuisine, food truck options and, yes, burgers and pizza for those times you just want a beer and something simple but satisfying.

Great food isn't the only thing that a restaurant has to have to make it memorable. Some places served wonderful food, but others were remembered for how the staff and owners treated them and the feeling of belonging and being a part of the community while they were there. When asking people which restaurants they considered iconic to Columbia, there were as many comments about a favorite server, a kind gesture by the owner or the fun they had with friends while they were there as there were comments about the restaurant's food.

What Columbia restaurants and food will be remembered and raved about in fifty years? Will it be the happy hours and Brock's green pepper rings at Murry's? Sloppy Disco Fries at 44 Canteen after catching a show at the Blue Note? The Nachos Bianco at Addison's? The sweet potato tots at Coley's? CJ's wings? What about the smoked brisket and mac and cheese sandwich from Como Smoke & Fire? Margaritas and Guacamole Mexicano on the patio of Las Margaritas? The rotisserie chicken dinner picked up from Hoss's Rotisserie & Market when you wanted to eat a great meal at home but not cook? Will people still be talking about the apple fritters from Harold's Doughnuts and the white Russian ice cream from

Matchbook collection of decades of Columbia restaurants. *Collection of Craig Brumfield.*

Sparky's? Only time will tell, but in the meantime, take pictures of your favorite dishes, snap a selfie with your favorite server or bartender and treasure those delicious memories.

Bibliography

Altrusa Club. Columbia, Missouri, Records, 1937– (C2305), State Historical Society of Missouri, Manuscript Collection.

Batterson, Paulina Ann. *The First Forty Years*. Columbia, MO: Columbia Chamber of Commerce, 1965.

Brendel, Martha. "Ed Johnson Plots His Next Move." *Columbia Daily Tribune*, November 28, 1998.

Burhans, Dirk. "Tradition Jeeps Nostalgic Drive-In Afloat." *Columbia Daily Tribune*, August 31, 2002.

Columbia Missourian. "A Guide to Columbia's Restaurants." 1992.

Columbia, MO Restaurants. State Historical Society of Missouri, Vertical Files.

Crighton, John C. Collection, a History of Columbia and Boone County 1821–1965 (CA2812), State Historical Society of Missouri, Manuscript Collection.

Dalton, Warren R., Jr. *Between the Columns*. Columbia, MO: Show Me Cards, 2010.

Daniel Boone Tavern. Columbia, Missouri, Formal Opening Program, 1917 (C3447), State Historical Society of Missouri, Manuscript Collection.

Deutsch, Jill. "Johnny Wright Dies Four Years into Sentence for Becky Doisy's Murder." *Columbia Missourian*, January 23, 2015.

Favignano, Megan. "Risky Business: How Do Restaurants Succeed Long Term?" *Columbia Daily Tribune*, August 19, 2017.

Fessenden, Edwin Allan. Scrapbook, 1905–1913 (C4220), State Historical Society of Missouri, Manuscript Collection.

Friedman, Steve. "Ernie's...Columbia's Chopped-Cow Palace." *Missouri Alumnus*, May–June 1979.

History of Boone County, Missouri—Written and Compiled from the Most Authentic Official and Private Sources. St. Louis, MO: Western Historical Company, 1882.

Hunt, Doug. *Reckless: The Life and Death of Richard Gentry.* Charleston, SC, 2010.

James, David A. *Historic Hotels of Missouri.* Columbia, MO: Show Me Cards, 2009.

————. (1937–). Papers, 1790–2008 (C4126), State Historical Society of Missouri, Manuscript Collection.

Keely, Mary Paxton (1886–1986). Papers, 1830–1983 (C0848), State Historical Society of Missouri, Manuscript Collection.

Keller, Rudi. "Columbia's Historic Sharp End." *Columbia Daily Tribune*, May 20, 2015.

McKenna, Patrick. "Emotions High as Downtown Columbia Shakespeare's Pizza Restaurant Demolished." *Columbia Missourian*, June 17, 2015.

Missouri Department of Natural Resources. "National Register of Historic Places, Multiple Property Documentation Form." Historic Resources of Downtown Columbia, Missouri. dnr.mo.gov/shpo/nps-nr/64500874.pdf.

Morris, Ralph L. (1913–1995). Papers, 1900–1993 (CA5655), State Historical Society of Missouri, Manuscript Collection.

Mueller, Karen A. "Dishing Out the Royal Treatment." *Columbia Missourian*, February 5, 1989.

Restaurant-ing through history. "The Decades." Accessed April 9, 2018. restaurant-ingthroughhistory.com/tastes-of-the-decades.

Rodgers, Genie, comp. *The Round Table 100th Anniversary Scrapbook.* N.p.: Boone County Historical Society, 2016.

Stanley, Owen. Postcards (P0436), State Historical Society of Missouri, Photograph Collection.

Sunday News and Tribune (Jefferson City, MO). "Columbia Café Owner Shot to Death." January 16, 1966. www.newspapers.com.

United Press International. "Branch Rickey, 83, Dies in Missouri." *New York Times*, December 10, 1965. archive.nytimes.com/www.nytimes.com/learning/general/onthisday/bday/1220.html.

Welch, John M. "Breisch's in Columbia Is a 'Carriage Trade' Restaurant with Popular Appeal." *Missouri Restaurant*, January 1961.

Williams, Walter, ed. *Historical Edition—Columbia Missouri Herald: Twenty-Fifth Anniversary, April 1895.* N.p.: Press of E.W. Stephens, 1895.

About the Author

Photo by William Linder.

Kerri Linder is a born and raised third-generation Columbian. She is a graduate of the University of Missouri with a degree in a very non–food nor history-related degree: accounting. After working in corporate accounting and spending time raising her children, she combined her passion for food, local history and meeting new people and started Columbia Culinary Tours, LLC. She enjoys sharing the history and stories of the town she grew up in and where she and her husband have raised their four children. When Kerri isn't scoping out new Columbia restaurants, you can most likely find her in her garden or on the sidelines of her sons' soccer games.

Visit us at
www.historypress.com